62 LESSONS

BASICS
—
CHARACTERS
—
SPECIAL EFFECTS

DRAW MANGA STYLE

A BEGINNER'S STEP-BY-STEP GUIDE FOR DRAWING ANIME AND MANGA

SCOTT HARRIS

QUARRY

CONTENTS

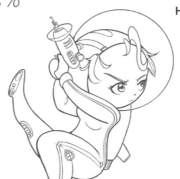

INTRODUCTION

I've drawn since I was young, but I was never any good at it—likely because I'm not particularly talented. I did, however, have a strong desire to get better, and as I continued to learn and practice, I began to see my work improve. My past work was consistently worse than my current work, which meant my future work would be better! I pressed on. This book has been created with this spirit, that anyone can draw well, and is meant to encourage *you* to press on and continue to learn and practice. You can certainly reach the level you desire!

The manga style originates from Japan and is influenced by Japanese culture and traditions. I encourage you to do your own research into the culture, language, and traditions of Japan. Drawing manga well means having a solid understanding of key art principles, too. In this book, you'll learn knowledge to help you form solid drawing fundamentals. Manga has a unique and distinct look to it that is often hard to re-create authentically due to many stylistic nuances. You'll be guided step-by-step as we dive deep into essential stylistic traits that will help you draw convincing and authentic manga characters.

Drawing well takes time and courage. Therefore, let me encourage you to, firstly, be patient with yourself as you learn and improve. Be consistent—it's better to draw a little every day rather than a lot once or twice per week. Secondly, be courageous; that is, overcome your fears. All artists struggle with approaching a blank page, failing, or drawing something that lacks appeal. You must learn to persevere past your fears and courageously move forward and keep drawing. Success in art is a by-product of many failures, so fail forwards—keep drawing and persevering to improve!

HOW TO USE THIS BOOK

This book is designed both as an instructional guide as well as a learning resource. The first 20 topics are dedicated to learning to draw manga characters from the ground up, and the remaining topics walk you through the drawing process of 42 characters in different poses and of different genres and themes.

The instructional sections should be used as reference points for your own work. Learning and memorizing the lessons taught in the first 20 examples of this book is critical for you to succeed in creating the characters you dream of making.

As for tools you will need to draw manga characters, some copier paper, 2B and HB pencils, fine tip markers for inking, and a normal and kneaded eraser will work just fine. If you prefer to work digitally, you'll need a drawing tablet with a compatible stylus and software, such as the iPad with an Apple Pencil, and Procreate, or a Wacom Tablet and Clip Studio Paint if you are working on a computer.

Anyone can draw well—don't forget that! I wish you the best as you start or continue your art journey into the character-filled world of manga drawing!

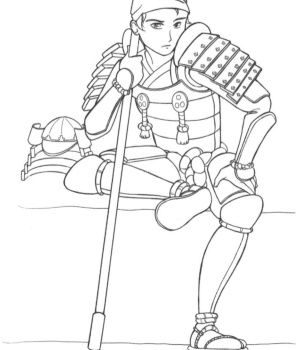

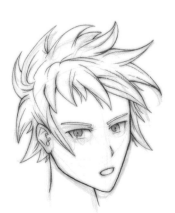

MANGA DRAWING FUNDAMENTALS

By learning some core drawing fundamentals, you'll be drawing manga characters in no time! The most important thing when starting is to never give up—we all start somewhere, and those that persevere, succeed! Please make sure to commit the lessons in this section to memory, as they are essential in helping you draw effectively.

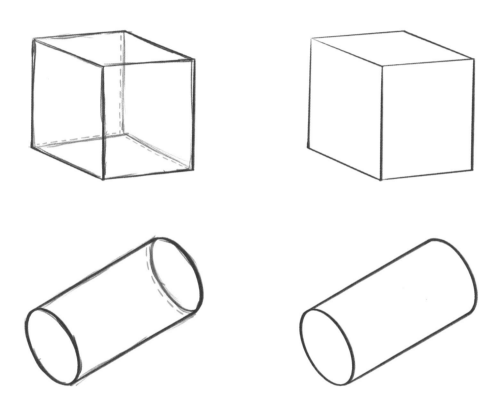

DRAWING IN 3D BY "DRAWING THROUGH"

Drawing in 3D is an essential part of character drawing, and this is done by "drawing through" our 3D shapes, called *forms*, imagining the other side of the object. We need to be able to understand the three-dimensional volume of character elements—even if just in a basic way—in order to properly place characters and elements in space.

Another way to think about "drawing through" is to imagine that you're creating 3D objects from wire. Typically when drawing characters, you will have multiple "rough" drawing stages, or planning stages, where you can use "drawing through" to help you plan. Following the planning stage is a cleaning up stage to refine the drawing and make it neat. In the example, you can see the 3D forms on the left are first roughly drawn by "drawing through" and then cleaned up and neatened for the final illustration on the right.

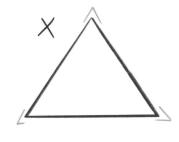

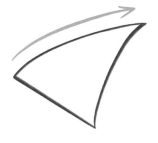

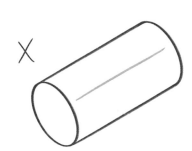

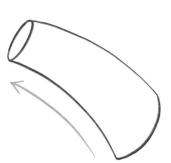

DYNAMIC SHAPES AND FORMS

When drawing, we want our manga characters to feel alive and in motion, even though they're really flat illustrations. One of the key ways to bring a sense of life and energy to our characters is by making sure we're planning our forms and flat shapes to be perceived as dynamic instead of static. A dynamic shape or form is one that seems to have a sense of "directionality"—that is, it appears to be moving or pointing in a direction. A static shape or form, on the other hand, is one that has no clearly perceived directionality.

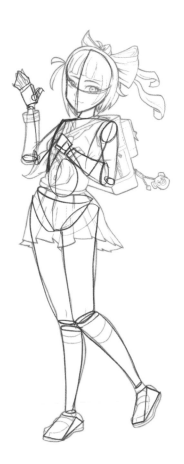

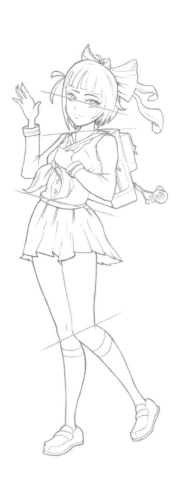

BUILDING WITH FORMS AND COUNTERPOSE

Left: When creating our characters, we start by building them out roughly, using basic building blocks. These building blocks are called *character forms* and are used in conjunction with counterpose, opposing curves, and lines of action to create dynamic and energetic characters. See page 14 for more information about character forms.

Right: Counterpose, or "contrapposto," refers to the asymmetrical counterbalance of the eye line, shoulder line, hip line, and knee line. Asymmetry in these elements helps a character feel more believable and well balanced and is visually appealing. This counterbalance can also be called horizontal tilts or vertical tilts if you are tilting elements via a vertical line instead.

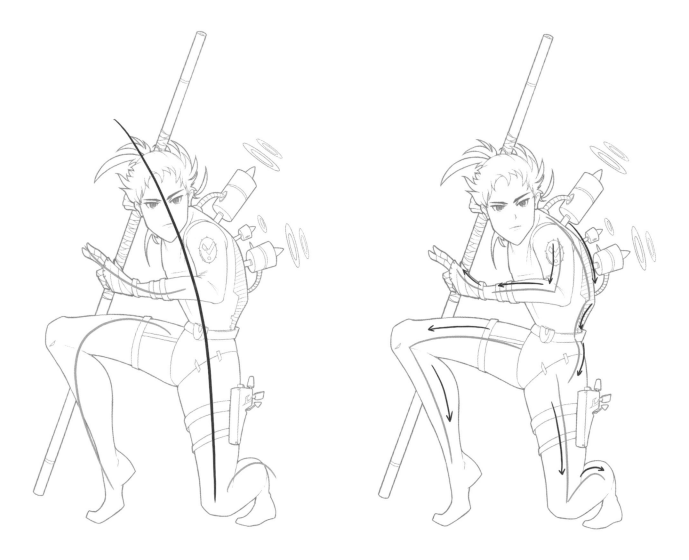

LINES OF ACTION AND OPPOSING CURVES

Left: The primary line of action is an invisible line that defines the overall directional movement of a character, usually as a C-shaped curve or an S-shaped curve leading in a particular direction. Secondary lines of action flow out from the primary line of action in a rhythmic or asymmetrical way and reinforce or contrast the primary line of action. We use these invisible lines to understand reference poses and when drawing our own.

Right: Opposing curves are a way of visually describing and dramatizing how energy moves through the forms of the character. Typically, if one major element has an inward oriented curve, the next major element will have an outward curve. We use this as a tool to bring asymmetry and energy into our character drawings, and it is especially important when building our rough drawings with the basic character forms.

MULTISTAGE DRAWING WORKFLOW

When drawing manga characters, we need a workflow to help guide us and move us from start to finish on a character. A drawing workflow consists of a number of steps that allow us to focus on a particular element of drawing, one step at a time, so that we don't get overwhelmed with all of the theory and get too "stuck" in the details. In this section, we will look at a 4-stage workflow. In each stage, we build off what we have done in the previous stages, drawing on top of our previous work.

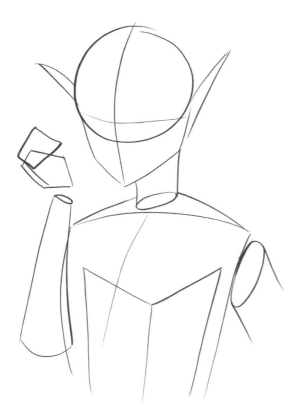

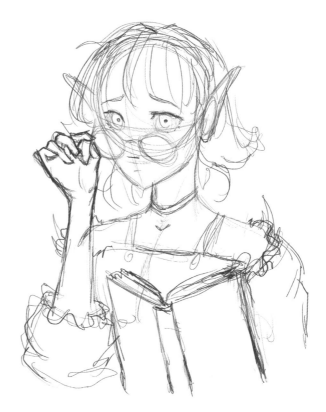

STAGE 1: PLANNING WITH DYNAMIC FORMS

In the first stage, the goal is to use the dynamic forms to build a solid foundation for the character. Posing and gesture are key here—you want these key elements to read well, without any additional details. Keep in mind counter-pose, lines of action, and opposing curves when drawing the dynamic form poses.

STAGE 2: ROUGH DRAWING

The rough stage is all about being relaxed, drawing quickly, and being experimental. Feel free to work rough and loose and don't shy away from being messy. Put the major elements of the drawing in and make sure that the proportions of the body and the face read well. In the rough stages, allow yourself to make any changes you like—never feel locked into a decision.

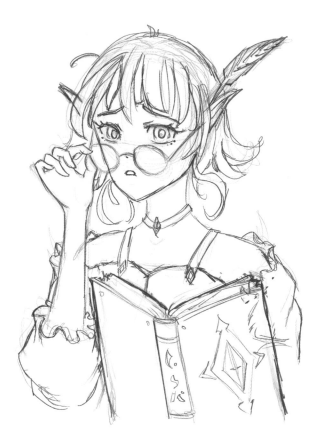

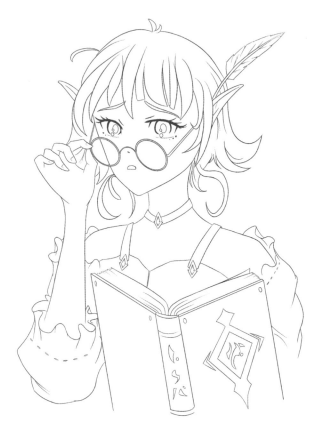

STAGE 3: REFINED ROUGH

Once you have settled in on the major elements, refine your rough drawing by adding in necessary details. Focus on clarity here, not on "neatness"—be careful not to fall into the trap of doing the cleanup stage too early. Stay loose and expressive. In this stage, you can clarify existing elements, and since it's still part of the rough stage, there's plenty of time to change your mind on things. Feel free to emphasize areas with line weights that can guide you when working on the cleanup and inking stage. Pay special attention to making sure the character's face and eyes, as well as their hands, read well.

STAGE 4: CLEAN UP AND INKING

The final stage is to clean up your work by drawing in clean lines, adding line weights, and adding in occlusion shadows. This specific stage is detailed more in the Inking section. When inking, you want to keep a posture of looseness. Strive for clear, energetic lines and know that it's okay to veer "off-plan" a little when drawing over your refined rough.

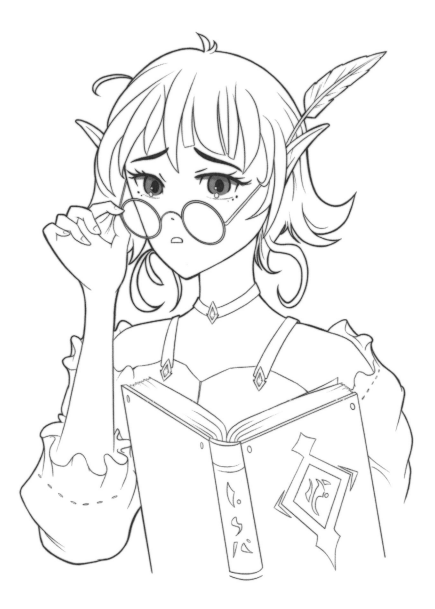

THE FINAL IMAGE

Once you have worked through the stages, you'll have a final image, which is ready for shading, screentones, or coloring. Using digital tools, you can also add in post-production effects or implement digital screentones.

THE TWO-STAGE WORKFLOW

When you're fairly experienced with this workflow, you'll find that the stages of planning, rough drawing, and refined rough begin to blend into one another. This is when you'll begin working using only two stages of drawing: a rough stage and a refined stage. In the rough stage, you will plan structure, composition, major elements, and so on, and in the refined stage, you will clean up, ink, and add finish to your work. As a beginner, focus on doing each stage one at a time, and as you progress, you'll naturally move into the two-stage workflow.

UNDERSTANDING LINES

Lines may seem simple, but they have many properties that, if used well, can help your drawings look natural and professional. Strive for confident lines, with varied line weight and value, and avoid tangents (unclear meeting of lines) by using overlapping lines.

CONFIDENT LINES VERSUS TIMID LINES

Confident, fast lines (example 1) have a smooth stroke edge, directionality, and natural variance in line weight. They make drawings look natural and professional.

Timid, slow lines (example 2) have an inconsistent stroke edge, flat ends with no directionality, and typically little variation in line weight. They make your work look uncertain and fearful.

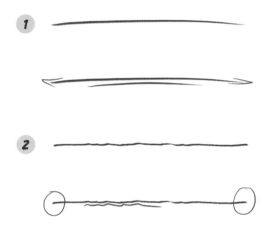

LINE WEIGHT AND LINE VALUE

Line weight (drawing 1) refers to the thickness or thinness of a line. The general rule is that thicker lines bring an object forward in space and thinner lines push an object backward in space.

Line value (drawing 2) refers to the darkness or lightness of a line. The general rule is that darker lines bring an object forward in space and lighter lines push an object backward in space. Darker lines can also bring attention to an area of focus.

TANGENTS AND OVERLAPPING LINES

A **tangent** (example 1) is any area where two lines meet but don't overlap.

An **overlap** (example 2) is where one line clearly overlaps another line. Tangents make it difficult for a viewer to discern where in space an object sits and create an unappealing visual abstraction. Overlapping lines help viewers clearly know what is in front and what is behind.

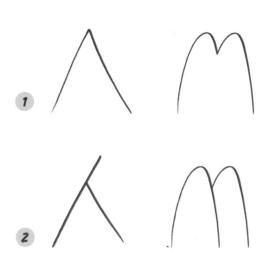

BASIC SHAPES

These are two examples of three basic shapes. Example 1 uses confident lines, variations in line weight and value, and overlapping lines. Example 2 uses none of these important rules.

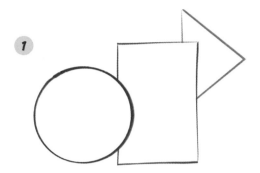

TWO SKETCHES, TWO DIFFERENT APPROACHES

Let's look at how two sample drawings of Akari the Schoolgirl (see page 44) are affected by this approach to lines. These aren't rough drawings, but clean sketches implementing two different approaches.

Good lines: Example 1 has natural, appealing line work, with variations in weights and values and appropriate overlapping lines to differentiate an object's position in space.

Bad lines: Example 2 conveys uncertainty and fearfulness, via a single line weight with no variation in value and many unappealing tangents.

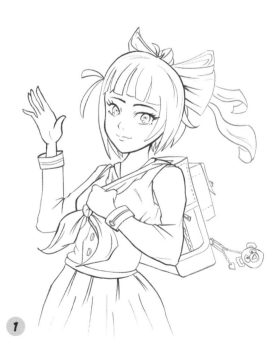

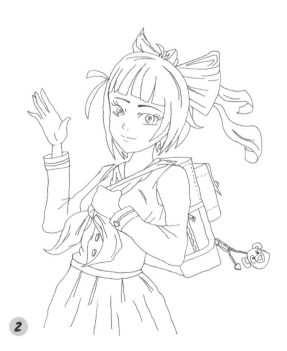

MANGA FIGURE PROPORTIONS

The term **proportions** refers to the size, spacing, and location of elements on a figure both overall, and in relation to one another. To make sure our characters' bodies look correctly proportioned, we use the head as the unit of measure. Once you've drawn the head, use your thumb and forefinger to measure its vertical length and then use that measurement to draw out the rest of the figure. Feel free to trace these diagrams to help you learn figure proportions by heart, which will greatly improve your efficiency and accuracy when drawing manga characters. Remember, you're learning a base for measurements and placement!

7-HEADS PROPORTIONS

Typically Used for Feminine, Female, and Younger Male Characters

This diagram uses a female figure to demonstrate typical 7-heads proportions, which can be used for many manga character types. When used for male characters, these proportions are usually used for younger male characters. For 6½-head proportions, compress the leg length slightly at the foot and keep the rest of the proportions the same.

IMPORTANT POINTS

- Total body length = 7 heads
- Length of torso from head to crotch line = 3 heads long
- Length of legs = 4 heads long (from the crotch line to the foot line)
- The breast or pectoral line is at 1½ heads
- The nipple line is at 1⅔ heads
- The ribcage line is at just over 2 heads
- The bottom of the ribcage and bottom of the elbows align
- The naval line is at 2½ heads
- The crotch line is at 3 heads
- The arm length is at 3⅔ heads
- The knee line is at 4½ heads
- The foot line is at 7 heads
- Shoulder width for female characters = roughly 2 heads across
- Shoulder width for male characters = roughly 3 heads across

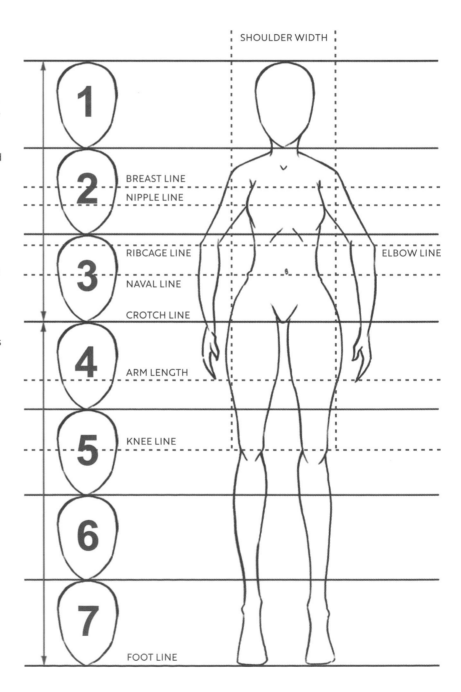

MALE AND FEMALE DIFFERENCES

The key difference between male and female proportions is essentially that male shoulders are wider than their hips and female hips are wider than their shoulders.

When drawing male characters, it's best to use straighter, more rigid lines. When drawing female characters, use curvier, flowing lines.

8-HEADS PROPORTIONS

Typically Used for Masculine, Strong, and Older Male Characters

This is a diagram for 8-heads proportions, which is considered "idealistic" and is used as a basis of realistic proportions for all kinds of character art. For manga drawing, 8-heads proportions is great for very strong and masculine characters or older male characters.

IMPORTANT POINTS

- Total body length = 8 heads
- Length of torso from head to crotch line = 4 heads
- Length of legs = 4 heads (from the crotch line to the foot line)
- The breast or pectoral line is at 1½ heads
- The nipple line is at 1⅔ heads
- The ribcage line is at 2½ heads
- The bottom of the ribcage and bottom of the elbows align
- The naval line is at 3 heads
- The crotch line is at 4 heads
- The arm length is at roughly 4½ heads
- The knee line is at 5½ heads
- The foot line is at 8 heads
- Shoulder width for male characters = roughly 3 heads across
- Shoulder width for female characters = roughly 2 heads across

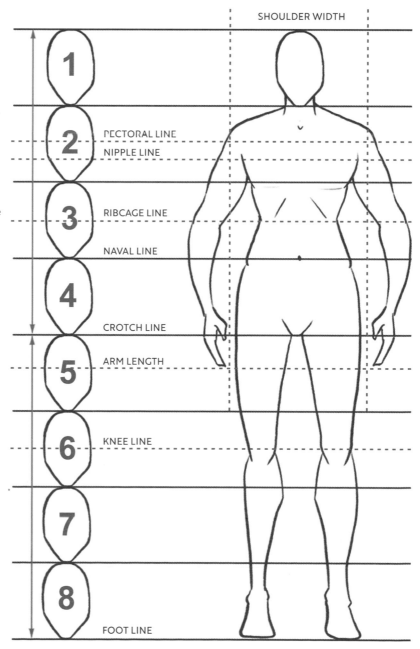

SHOULDER WIDTH

1

2 — PECTORAL LINE / NIPPLE LINE

3 — RIBCAGE LINE / NAVAL LINE

4 — CROTCH LINE

5 — ARM LENGTH

6 — KNEE LINE

7

8 — FOOT LINE

BASIC CHARACTER FORMS

When building out the rough base of your character, using some simple and dynamic basic character forms is critical to posing your characters well. There are many ways to start the rough structural base of your character, but I have found that by combining the understanding of opposing curves, dynamic shapes and forms, and horizontal tilts (contrapposto) with these basic forms, you can quickly design energetic and expressive poses for your characters.

Each core form has been illustrated here for you to memorize. Practice drawing these by "drawing through" and creating your own rotations and angles. You can bend them and change them as needed—your key goal is not to necessarily capture the anatomy perfectly at this stage, but instead to create a solid, believable gesture and pose. Remember to always draw in three dimensions, consider the lines of action, and keep in mind the proportions you'd like your character to have. Add a center line to each form (see examples) to help you lock in the direction the form is facing, as well as to establish the center of each component to assist you in drawing in other elements later on.

One last thing—both these basic character forms and the sample poses on the next pages have been drawn more neatly for clarity; however, when actually creating your characters, these basics can be done without a care for neatness and can be drawn quickly and roughly. The rough plans have been left intact on the examples for you to see.

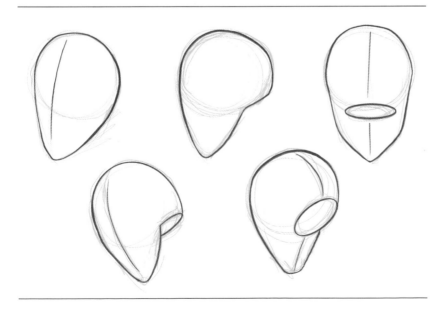

Head Forms: These can be drawn initially as a sphere, with a protruding mass to indicate a jaw and chin. A flat section rests below the rear of the sphere for the neck form to be inserted.

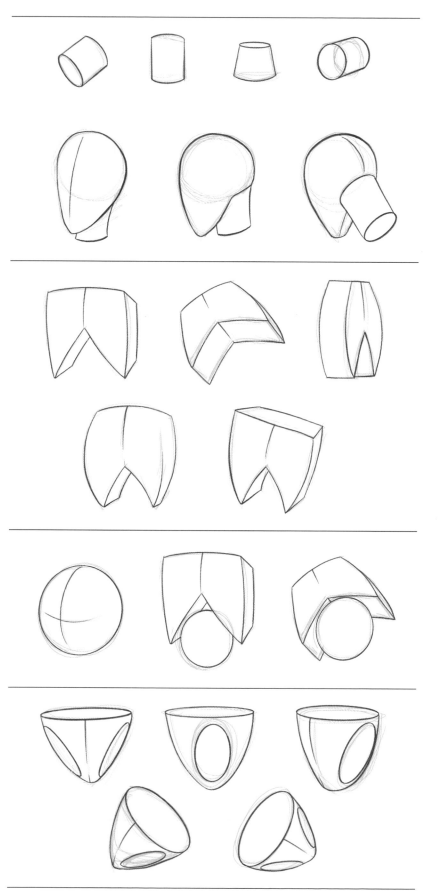

Neck Forms: A basic cylinder or a slightly bent cylinder (for a more dynamic form) can be used to plan the neck.

Chest Forms: The chest forms are fundamentally based on the design of the ribcage. Their shape can be either rounded or squared off, and you can increase or decrease the shoulder length depending on the age or gender of the character you are drawing.

Mid Form: The mid form is a simple sphere, which is where the stomach and core rotation would be. It rests inside the upside down "V" shape in the chest form. Note how the center lines help distinguish the circle as a sphere.

Pelvic Form: The pelvic form is a cup-shaped form with two ovals on each side to denote the general location of where the upper legs protrude. The simplest way to draw this form is to start with an ellipse and then bring the edges into a "V" shape.

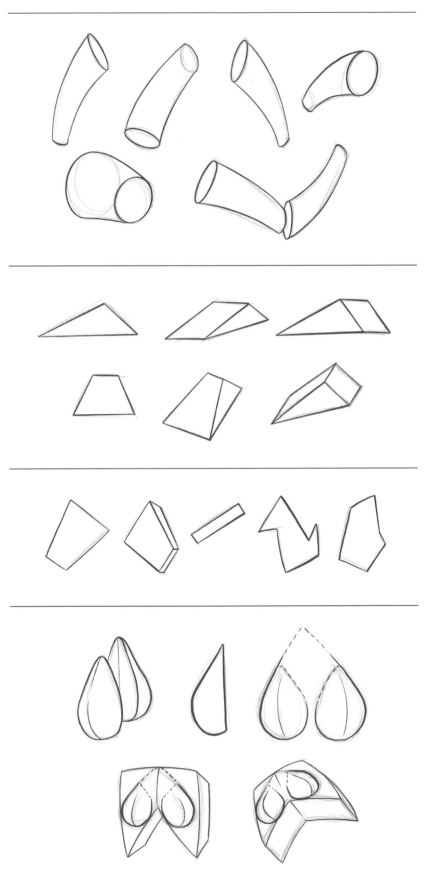

Arm and Leg Forms: The arm and leg forms are essentially cylinders bent into dynamic forms, with one end smaller than the other. Both arms and legs use these basic forms in an opposing curves fashion (see examples).

Foot Form: This basic shape can be a dynamic form or a static form and is used to denote both the right and left leg. Note that the "heel" end is a shorter angle than the "foot" end.

Hand Shapes: Hands are as complex to draw as the entire body itself! Using simple shapes or very basic forms in the planning stage is the best approach. We will look more in-depth at hand drawing later on.

Breast Forms: A good way to contemplate the shape of breast forms is to envision a teardrop that's divided in half. Positioning the breast forms on the chest form can be done by roughly drawing an upside-down heart shape and then drawing the forms in. While this is not anatomically how breasts work, it's a good strategy for fast and accurate form placement.

POSING WITH CHARACTER FORMS

On this page are sample poses of both male and female characters using the basic character forms described previously. Your goal in posing is to always capture a clear gesture—one that clearly communicates the essence of the character's movement and emotions. Use the basic character forms as you see fit and bend them and change them as you need to achieve the pose you want. I also highly recommend utilizing pose references to help guide you when drawing your rough planning sketches. Feel free to use or change these poses for your own characters!

Once again, the following character forms have been drawn more neatly for presentation, but when drawing your own, feel free to be as rough and as loose as you like. Clarity is more important than neatness when doing your early-stage planning.

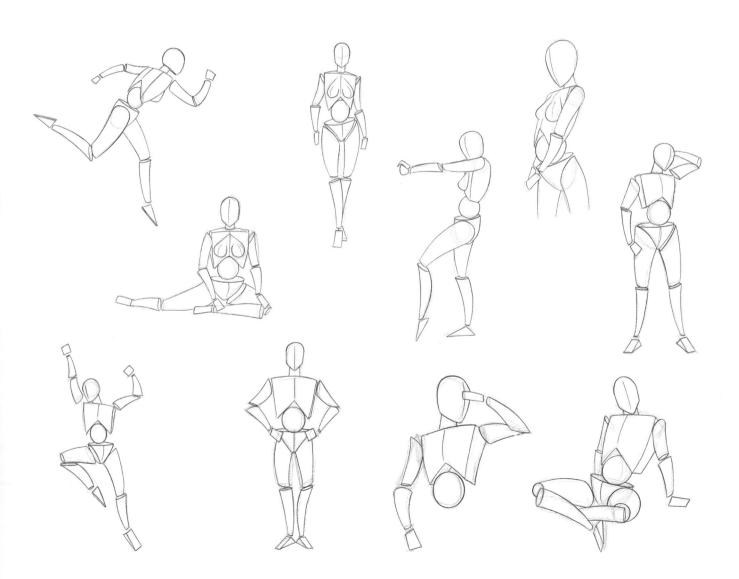

DRAWING FEMALE MANGA HEADS

Drawing manga heads is all about proportions and following our drawing workflow (see pages 7–10). Let's first take a look at manga head proportions using a girl's head as an example. Keep in mind that girls tend to be drawn with curvier lines, such as the jaw and cheek lines, and have exaggerated eyelashes and often smaller noses. Manga head proportions are as important as body proportions—become familiar with them, but keep in mind that they are only guidelines.

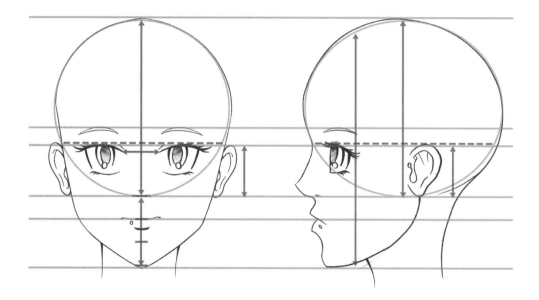

There are some important observations to be made when looking at the proportions of the head:

FRONT VIEW:

- We begin with a circle and add roughly one third of the circles space below the circle to determine the bottom of the chin.

- The tops of the eyes are positioned at the bottom third of the circle.

- The eyes are approximately one eye's width apart from one another.

- The nose is at the very bottom-center of the circle.

- The height of the ears starts at the top of the eye and extends to the bottom of the nose.

- The mouth line is determined by dividing the space between the nose and chin into thirds and placing the line on the top third dividing line.

SIDE VIEW:

- In the side view, the proportions are the same, but take note that the circle base is ovular and that the ear is placed just behind the center line of the oval.

- The facial features are positioned in roughly one-third to one-quarter of the oval, divided vertically.

- The jaw line connects from the chin to the bottom of the ear.

Look at the below examples of female manga heads and observe how the proportional guidelines are used. As you draw more and more, you'll be able to "bend the rules" by playing around with different types of proportions, while still maintaining appeal.

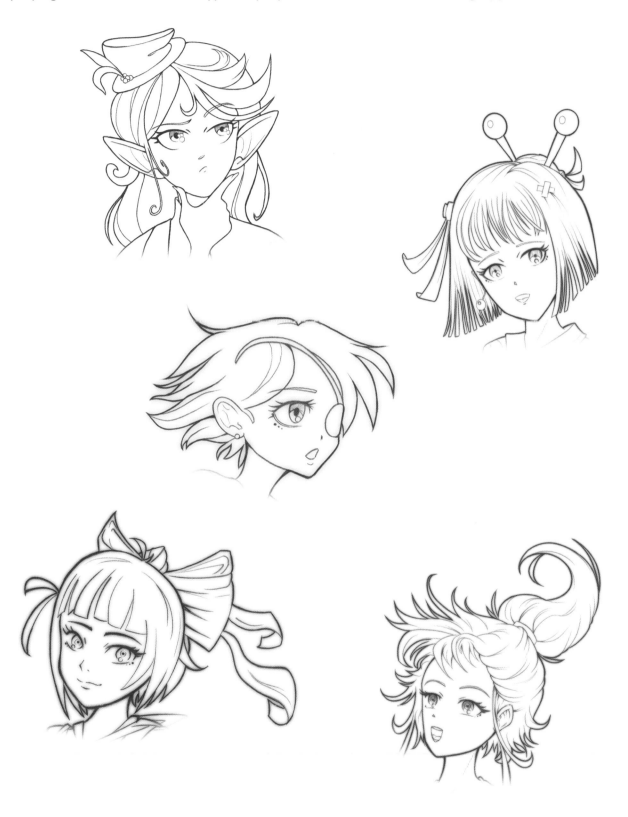

DRAWING MALE MANGA HEADS

Male proportions and female proportions don't differ, but we want to keep in mind certain traits of male heads. Guys tend to be drawn with straighter lines and more angles, thicker necks, and a more prominent jawline. Typically, eyelashes are understated, and noses can be drawn slightly larger.

THE HEAD DRAWING WORKFLOW

Drawing heads follows a standard workflow.

1. We begin by drawing out our basic forms for the head, keeping in mind the proportions.
2. Roughly draw in the hair and facial details.
3. Add in clean lines and line weighting.
4. Finish up with a clean outline.

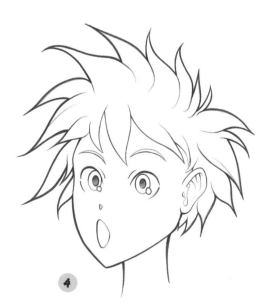

Take a look at the examples below of male manga heads and observe how the proportions are used. Sometimes, it can be very easy to make a guy look like a girl or to make a girl look like a guy, so pay attention to the nuances and traits of each!

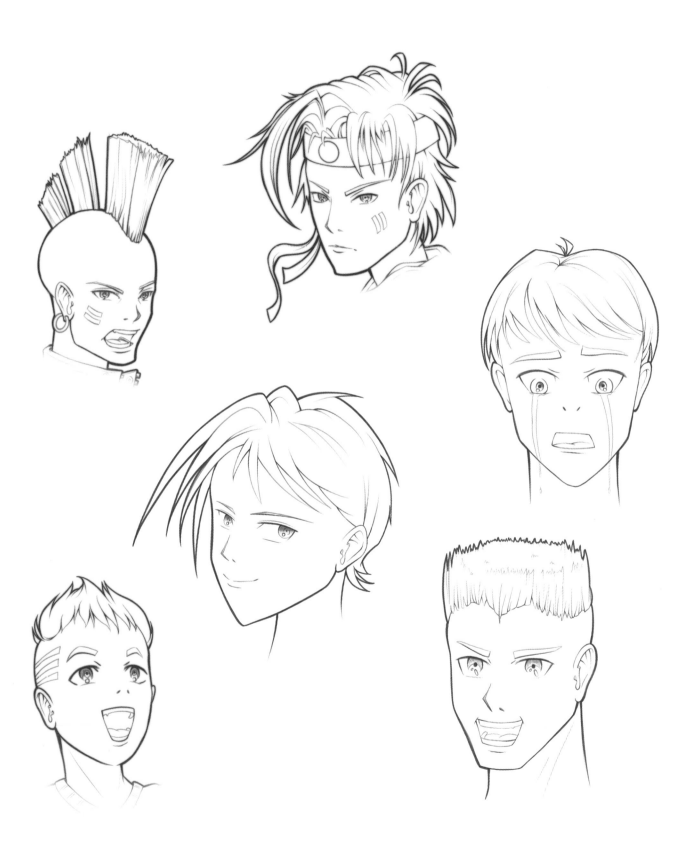

DRAWING MANGA EYES

Drawing manga eyes is more fun and more straightforward than you might think! With a few simple principles that you can then adjust to achieve your own look, you'll be drawing manga eyes in no time.

MANGA EYES ARE LIKE STICKERS

Many manga eye styles are essentially flat graphic shapes that represent eyes, rather than being based on a spherical form and wrapping eyelids like a real eye. A good way to think about manga eyes is to see them as "stickers," and doing so will help you to correctly proportion them on characters' faces when drawing heads at different angles.

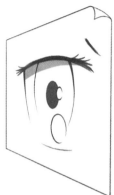

STEPS TO DRAWING MANGA EYES

Most manga eyes have the following parts in common. You can follow these 9 simple steps to draw the key parts of a manga eye. Consider this your foundation for drawing the eyes, so make sure to remember this technique.

1 Draw the upper lid line with a few lashes on each end.

2 Add in the outer eye line; make sure it's a dynamic shape!

3 Add in a lid crease line.

4 Draw in two curved lines to indicate the iris; make sure they're dramatic!

5 Add in a thinner lower lid line.

6 Draw in a simple pupil.

7 Lightly shade in an eyelid shadow.

8 Finally, add in your highlights, typically one on both the iris and pupil.

9 Here is a completed eye with cleaned up lines.

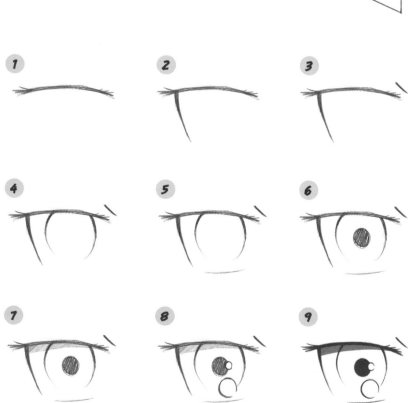

VARYING YOUR EYE DESIGNS

There are many different styles of manga eyes, and creating your own unique style is fun and easy. Simply adjust the size, angle, and proportions of the elements to create all new authentic styles. Try making the pupils bigger or smaller or leaving them out. Add more or less highlights, changing their shapes. Adjust the shape or thickness of the upper lid and the angle of the outer eye line. Create additional iris lines or an inner eye line, extend lashes and add lower lash shapes, and much more! The varieties are truly endless.

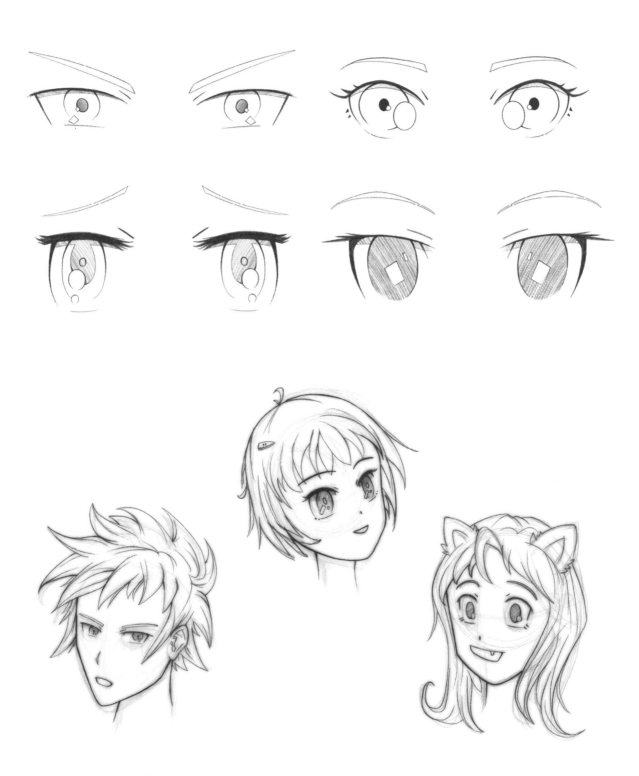

DRAWING MANGA EARS

Drawing ears is easier than you think! Since ears are typically not a focal point, a simple but effective way of portraying the ears is easily learned. When we consider the form of the ear, it's very much a flat, angled cylinder protruding from the head.

SIMPLE EAR DRAWING STEPS

While I would always recommend doing your own in-depth anatomical studies, sometimes a simple step-by-step approach is best. Follow along with the below drawings, imitating each different colored step, and then practice drawing out the ears on your own. Memorizing this method is a great help—as you'll see throughout the book, I draw all my ears like this! To draw ears from a side angle, simply "squish" the shape and make sure to overlap the upper lines marked in red.

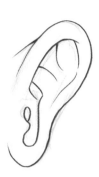

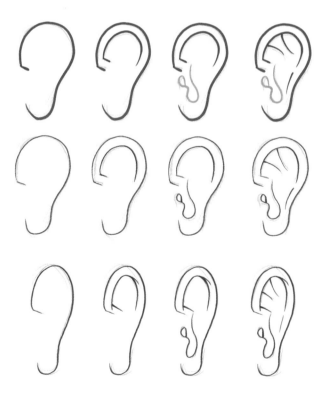

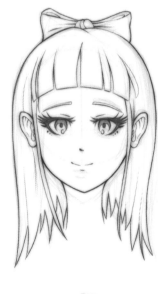

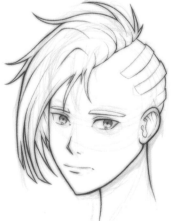

DRAWING MANGA NOSES

Real noses are complex and nuanced, but in the world of manga and anime, they tend to take on an iconographic or symbolic form. That's not to say that all manga has simplified noses, but it is a very common approach.

EASY-TO-DRAW MANGA NOSES

Learning and mastering these manga nose shapes will give you a good amount of nose variety as you create your characters. In the below examples, you will see different approaches of drawing the nose from left facing to straight ahead to right facing, as well as some side examples. Draw out some rough character heads and try out different nose styles to see the difference they can make.

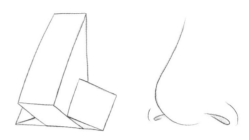

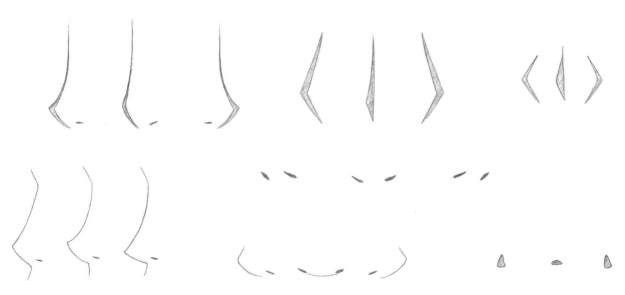

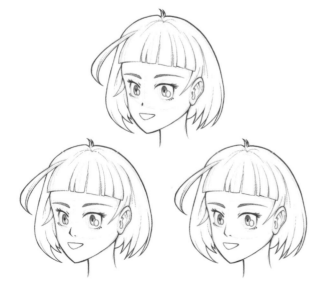

THE NOSE KNOWS

A nose can make a huge difference to how a character looks, both in terms of its shape and in terms of its size. Consider how the nose affects each version of the same character.

DRAWING MANGA MOUTHS

Manga mouths are typically drawn as iconographic symbols, rather than actual mouths, but this is not a hard-and-fast rule. Understanding the underlying structures of mouths is important to drawing them well, whether simple or complex, and will be a boon to helping you understand how to make better character expressions.

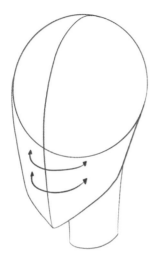

Notice the curvature of the front of the face as it wraps around to the side of the head. This is very important to remember as you're placing your mouth lines on the face. Drawing mouths without consideration for this wraparound will result in very flat looking and unappealing mouths.

The jaw's lower half moves up and down as characters talk and express themselves (and chew!). As the jaw extends downwards, the skin stretches down and the chin moves lower, and this motion gives the face a stretchiness. When drawing various open or moving mouth expressions, keep in mind that you'll need to adjust your characters' faces accordingly to show the stretching and squashing that occurs.

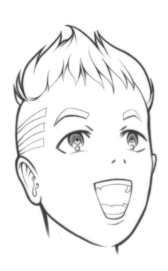

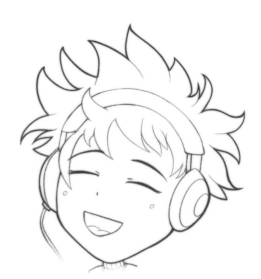

Below are some sample mouths for you to use and experiment with. Try adding these mouths to different heads, remembering to wrap around the face, and consider the movement of the jaw.

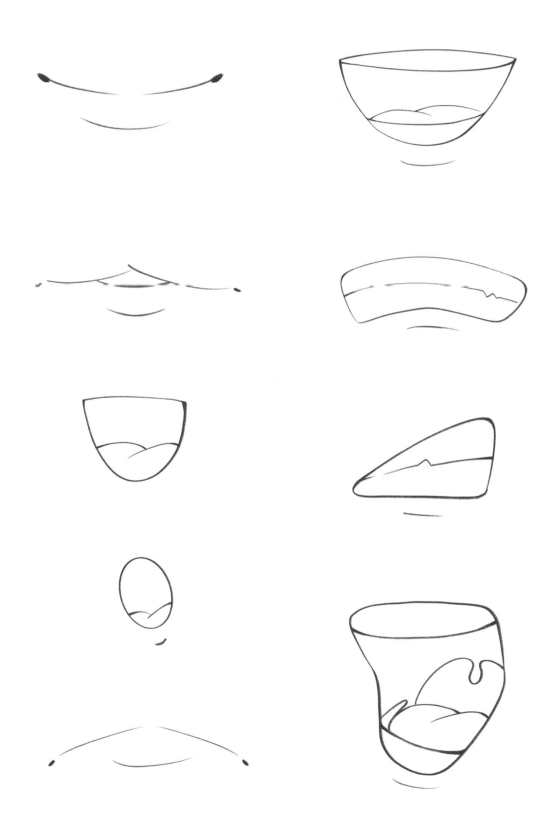

DRAWING MALE HANDS

Hands have proportions, just like bodies and heads, and since hands are considered secondary focal points in character drawings, it's important to know these proportions well. Drawing hands can be very tough even for experienced artists, so make sure to use as much reference as you need—and your own hands!

HAND PROPORTIONS

HAND PROPORTIONS MEASUREMENTS

- A circle is used to determine the size of the palm.

- The circle is divided into four quadrants, and a lower quadrant is used to determine the position of another circle, which indicates the base of the thumb.

- The middle finger is then drawn in, which has the same height as the circle.

- The remaining fingers are drawn in, with the height of the index finger and ring finger slightly shorter than the middle finger and the pinky finger being the shortest.

- The thumb then protrudes from the smaller circle.

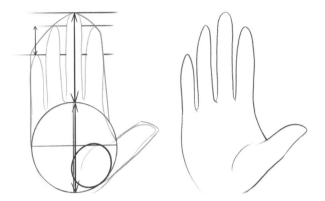

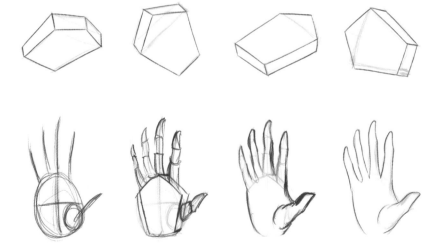

HAND DRAWING WORKFLOW

A solid form for drawing the hands is shown below—this form helps easily give you the height of the fingers without having to remember individual finger sizes, so you can draw them at the same size and not worry. Here is the standard workflow for drawing hands:

1 Start with the basic proportions and add curved or opposing curve lines to represent the fingers.

2 Draw in the palm form and add smaller curved cylinder forms to represent the fingers and their joints.

3 Roughly sketch in the skin and details.

4 Finish with clean lines on a new page or layer.

Feel free to use these hand drawings as references when practicing. Speaking of practice, hands take a lot of work to master, so let's get started!

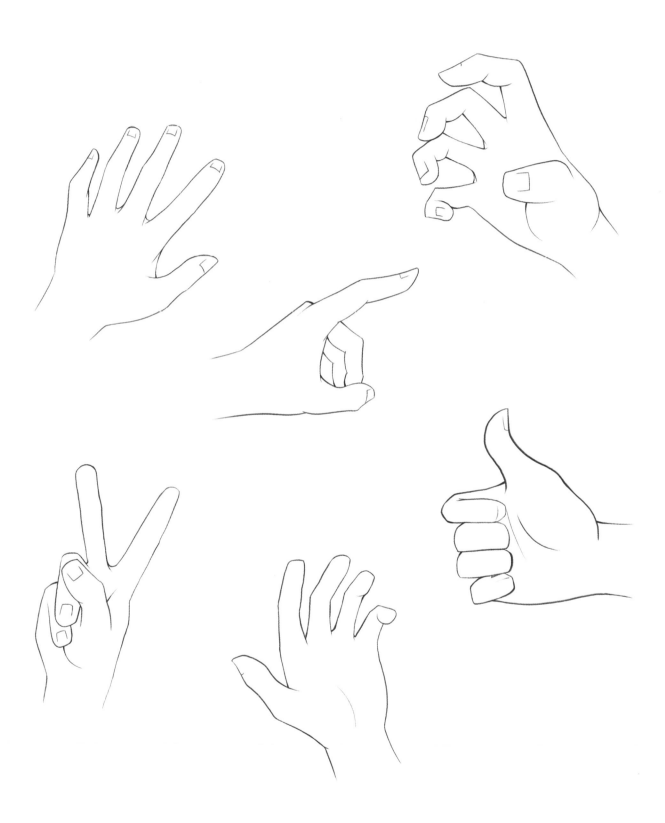

DRAWING FEMALE HANDS

While female hands are drawn in the same way as male hands, they feature more curved lines and pointier tips to imply longer fingernails typical of manga female characters. Use as much photographic or real-world reference as you need—it will make all the difference!

FEMALE VERSUS MALE HANDS

Female hands tend to have more curves, while male hands tend to use straighter lines. Female fingertips also end in more of a point, where male hands are stubbier and more squared.

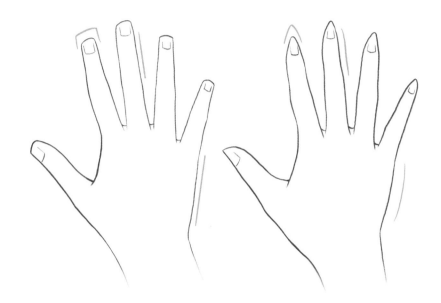

DRAWING FINGERNAILS

When drawing fingernails, often it's best to imply them rather than to draw all their edges; the viewer's imagination "fills out" the details.

Drawing 1. The full fingernail has been drawn. This approach can be too realistic and detailed for manga, depending on the style.

Drawing 2. The cuticle line and two fading lines indicate the edges of the fingernail.

Drawing 3. This approach—showing two nail edges coming off the tip of the finger and leaving out the cuticle line—is quite common in manga.

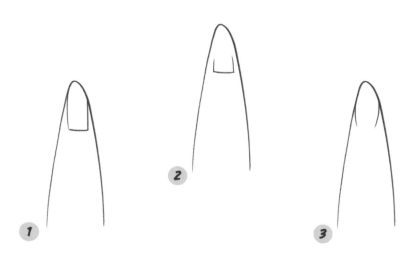

STEP-BY-STEP: DRAWING A FEMALE HAND

This sequence is an example of how you might approach drawing hands. Ultimately, you'll want to implement each rough step (steps 1 to 3) simultaneously as you improve.

1 Using your reference, draw a **rough skeleton** using the basic hand proportions (page 28) as a guide. Draw out the circle of the palm, the circle marking the base of the thumb, and use two basic opposing curves for each finger.

2 Draw **dynamic anatomical forms** using the rough skeleton as a guide. Be clear with your overlaps and use your reference image to help you position the forms correctly.

3 Create the **rough sketch** over the dynamic anatomical forms.

4 Clean up the sketch using **fast**, **confident lines**, varying line weights where necessary.

FEMALE HAND POSES

Use these poses as inspiration for your own drawings and to get a feel for the nuances of drawing female hands.

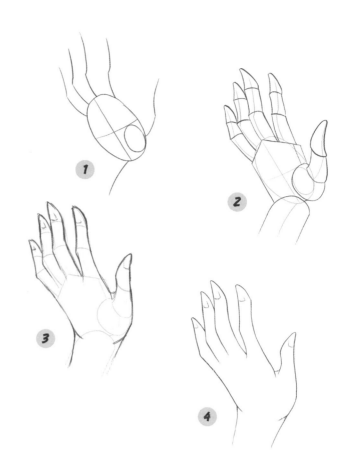

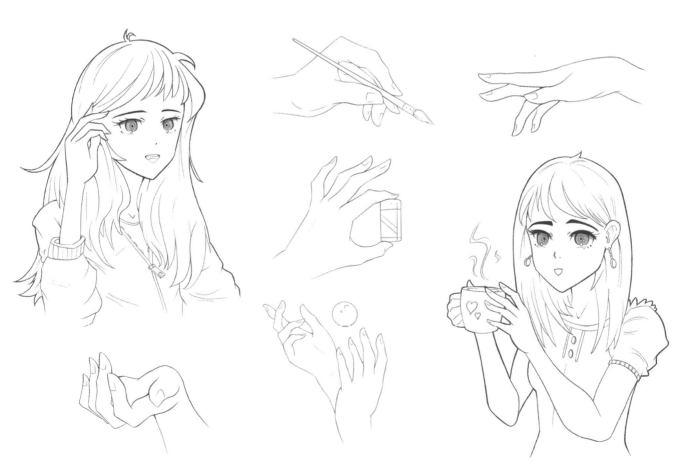

DRAWING FEET

Drawing feet can be as complex as drawing hands, but with good references and a solid workflow, they can be drawn confidently. A simple prism-like form is used to represent the foot overall. By "slicing off" a section of the front edge, we can imply the location of the toes. If we add some dynamic shape to those forms, we create a solid foundation on which to draw our foot!

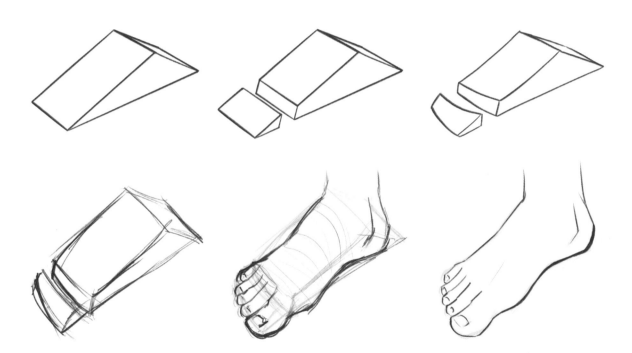

A WORKFLOW FOR DRAWING FEET

Like other workflows, drawing feet has a familiar flow to it. I definitely recommend using references when drawing feet, since their diverse angles and range of movement can make them very difficult to draw convincingly from your imagination alone.

1 Start off by loosely drawing in the dynamic forms and making sure the size of the toe shape from the smaller toes to the big toe reads well.

2 Create a rough sketch, striving to place each element accurately.

3 Refine your rough sketch with clean lines and line weights to finish.

Feet can be as expressive as hands in communicating how your character feels or reinforcing their emotions in a pose. Use these typical foot poses to help you draw feet at varying angles.

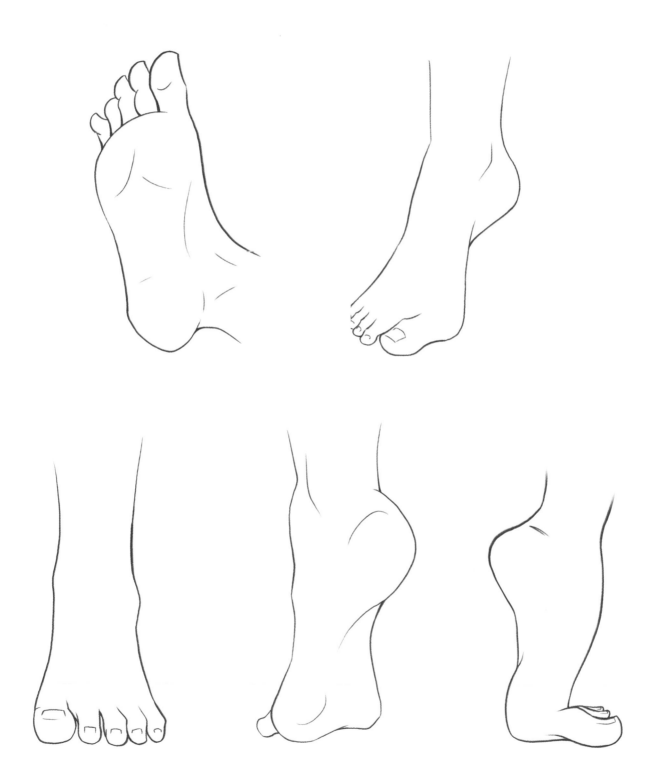

MANGA HAIR FUNDAMENTALS

Hair should be dynamic, full of volume and movement, and add extra personality and attitude to your characters. Let's take a look at some key elements to drawing manga hair successfully.

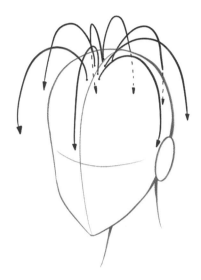 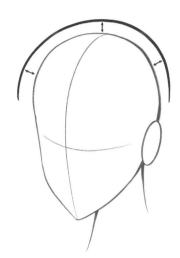 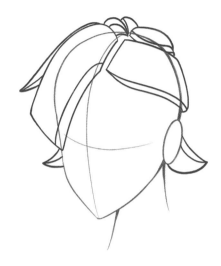

HAIR SPROUTS

Hairs sprout from their roots on the top of the head and flow over the back, front, and sides of the head. Of course, different types of hair can react differently depending on both the weight of the hair or the curliness of the hair, but its sprouting nature remains the same. Keep in mind the type of hair as you draw it and consider gravity's effects on it.

HAIR HAS VOLUME

As individual hairs sprout from the top of the head, they layer on top of one another, causing the hair to have a build-up of volume. To show this in our drawing, we make sure to always draw the top of the hairline a short distance away from the head. This is a very important thing to remember! Hair does not "stick" to the head, it "floats" above it a little because of the volume build-up. Only when hair is wet or has gel in it does it tend to stick to the head.

HAIR COMES IN CLUMPS

Hair tends to fall into natural large groupings of separate clumps. We don't want to be drawing hair as individual strands—this would not look good. Instead, we focus on roughly planning out our characters' hairstyles by drawing basic forms, or clumps, of hair that are 3D and wrap and flow around the head.

HAIR DRAWING WORKFLOW

When drawing hair, keep two very important things at top of mind. First, work from *big to small*; that is, from big overall shapes to small details. Second, make sure you're being *very* loose and flowy with your lines. So keep your arm loose and let your lines flow smoothly.

1 Start with the basic overall shapes that you want, keeping in mind sprouting, clumping, and 3D forms, and be as loose and flowy as possible.

2 Draw in additional strands and details. Make sure that whatever lines you add to the hair overlap or are in some way connected to the existing hair lines.

3 Complete your drawing with clean lines and line weights. Keep in mind that typically we want inner hair lines to be thinner and lighter than outer hair lines.

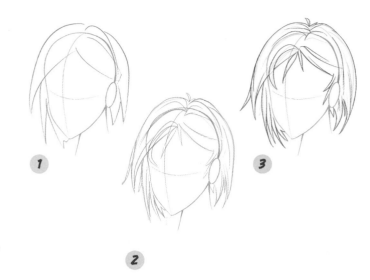

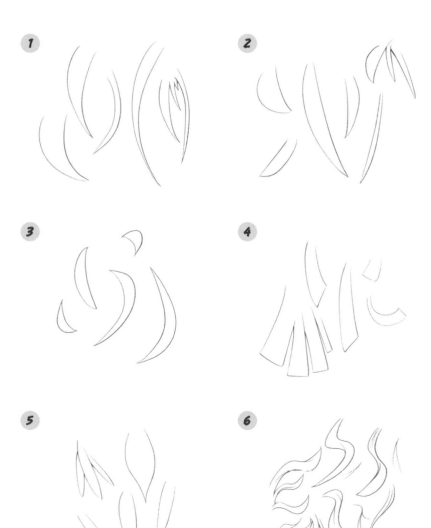

TYPES OF HAIR STRANDS

Studying the different types of hair strands commonly seen in manga will help you fast-track your hair drawing and give you a great base to work from when designing your own hair styles.

1 **Curved strands** end in a point, and both lines curve the same way. Always vary the size of the strands when drawing them next to one another.

2 **Blade strands** end in a point, but one of the lines is typically flatter, with the other being more curved.

3 **Flick strands** are curved strands or blade strands that end in a point on both sides. They're useful for adding extra strands of hair that appear to "stick out" of the hair clumps.

4 **Flat strands** end in a flat line and are useful for conveying hair that has a clean, solid cut across multiple strands.

5 **Parallel strands** have opposing curves on each side that parallel one another. They're useful for breaking the flow of other strand types that move in one direction.

6 **S-curve strands** help show curls and waves in hair and convey a sense of springiness.

DRAWING DYNAMIC MANGA HAIR

Hair is extremely dynamic and can be arranged and styled in countless ways. Use the styles on these pages as a baseline for your own unique designs.

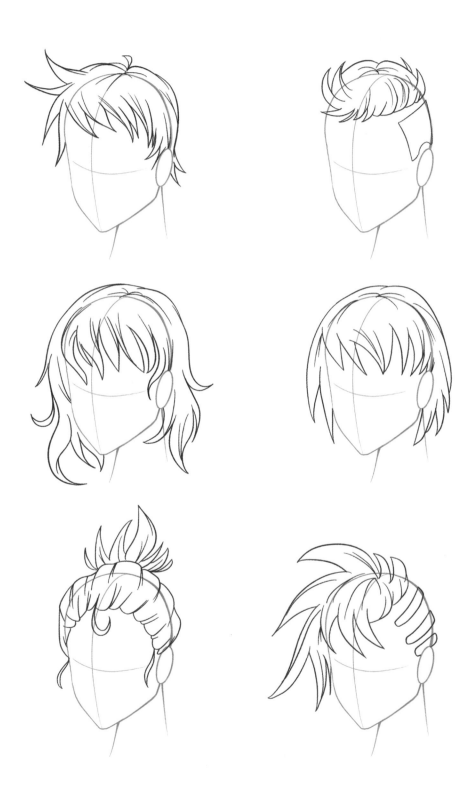

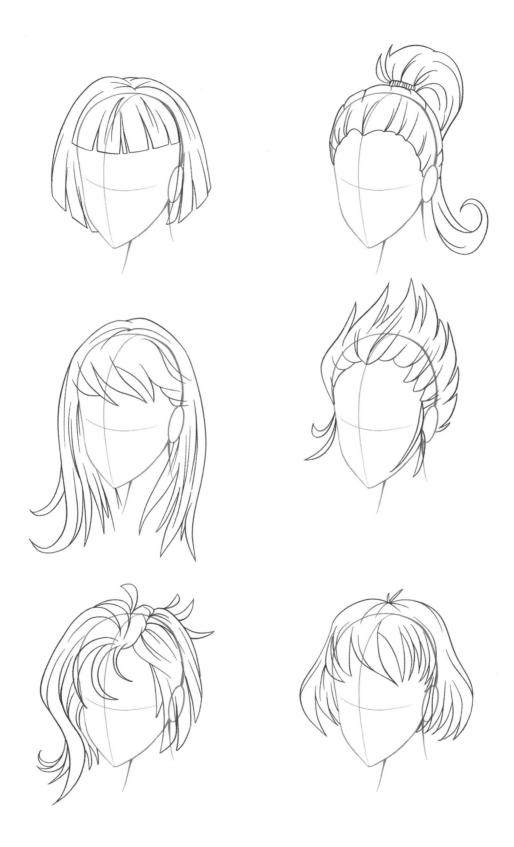

INKING MANGA CHARACTERS

Inking is the process of refining and cleaning up your drawings, giving them a clean and professional look. Inking, or creating clean line-art, can be done traditionally with multiliner pens and brush pens or digitally on a computer or tablet.

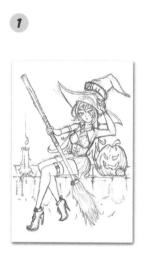
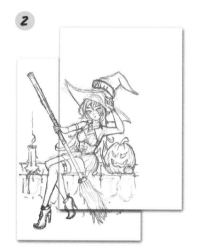
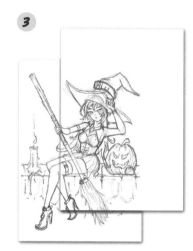

STEP 1: PREPARING YOUR DRAWING

When you've completed your drawing and are ready to ink it, you can do so in one of three ways.

1 If you're working on paper, you have two choices. The first option is to lighten your drawing with a kneaded eraser and ink on top of the drawing (make sure to do a final erase of the pencil when you're finished inking!).

2 The second option is to place a new sheet of paper over your drawing and ink on the new sheet.

3 If you're working digitally, you can lighten the drawing layer by lowering the opacity and then adding a new transparent layer on top to ink it.

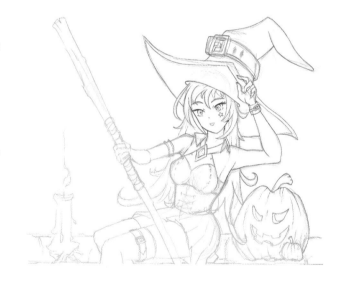

STEP 2: DRAWING IN THE CLEAN LINES

Using a set line thickness or line weight, do a single pass over the entire drawing, making sure the lines are dynamic and clean. Certain key areas can have some lines thickened or weighted, such as the edges of the face or major overlaps.

STEP 3: ADDING LINE WEIGHTS

Using what you learned from the lesson on understanding line weights, thicken lines where one element overlaps another. Use your discretion to determine the areas where this is most essential.

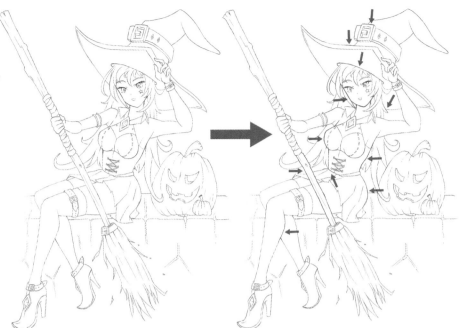

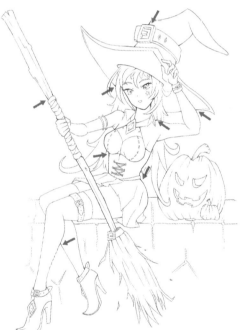

STEP 4: DRAWING IN OCCLUSION SHADOWS

Occlusion shadows are triangular-shaped shadows that are drawn on a line being overlapped, as opposed to the overlapping line. The triangular shadow is drawn from the start of the line being overlapped, and the point of the triangle tapers into the rest of the line. Take a look at the areas marked in the image and see if you can find occlusion shadows that haven't been pointed out.

You can do each step of this process linearly, or you can do them all at once, whichever works best for you. Depending on the look you are going for, you may want to also consider adding a thicker outer line weight on your characters for a chunkier look, or alternatively use significantly thinner, clean lines overall for a sleeker look.

CHARACTER AND COMIC EFFECTS

Manga is full of varying effects that help bring the viewer deeper into the story or the character. Some effects help reinforce a scene, an action, or a character's mood, and others help the reader to better understand the character's speech or to convey a sense of elemental power.

SPEED LINES AND ACTION LINES

Speed lines and action lines are parallel lines that may or may not fade at one side. Speed lines are parallel and can convey fast movements or highlight the sudden appearance of a character. Action lines converge and can be used in the same way as speed lines, as well as being used to emphasise an emotion or highlight an important object, place, feature, or action.

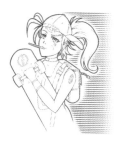

SPEED LINES

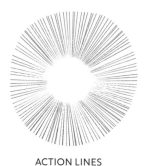
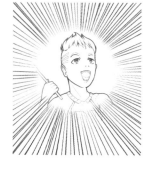

ACTION LINES

SPEECH BUBBLE VARIATIONS

Basic speech bubbles are used for normal speech, while dashed line bubbles are used for whispers. Webbed line bubbles are used for characters that are yelling, and spiked bubbles are used for announcements such as radio, TV, or intercom systems.

ELEMENTAL EFFECTS

Powers that are magical, mutant, or otherwise are a staple of manga and anime. In this example, steam, fire, and electricity have been drawn by using curved, opposing curved, and straight lines to convey the nature of the different elements.

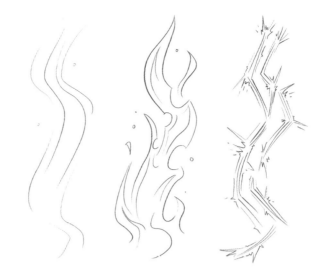

EMOTIVE SYMBOLS

Many manga use simple, clear symbols for reinforcing a character's emotions. Sweat drops can be used for stress, worry, exertion, or frustration when paired with the right facial expressions. Lines on the cheeks are used to show a character blushing or flustered, and a head vein symbol is used to show anger, rage, or intensity. There are plenty more to discover (or you can create your own!).

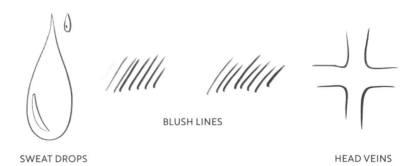

SWEAT DROPS

BLUSH LINES

HEAD VEINS

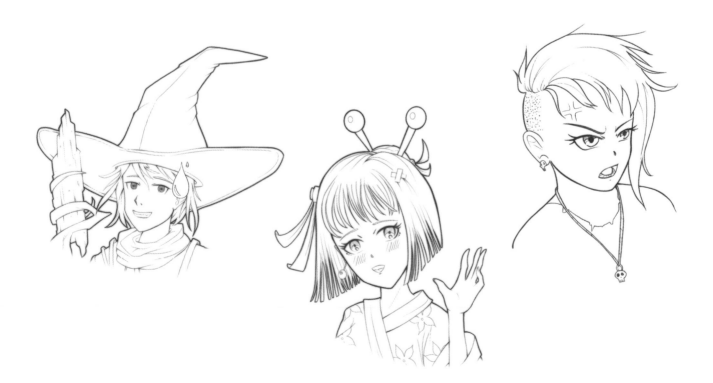

BASIC CHARACTER SHADING

Welcome to this bonus lesson on shading characters. Let's look at a quick and easy way to do basic character shading, whether working in pencil or digitally. This method will give your characters a fast three-dimensional look.

STEP 1: DETERMINE YOUR LIGHT SOURCE AND SOFT AND HARD EDGES

It is important for us to imagine where the main light is in the scene and what direction it is pointing. It can help to draw an arrow or another marker to keep as a reference point. We will also want to use two kinds of edges when doing basic shading: a soft edge and a hard edge. If you are working with pencils, you can create a soft edge by gently shading with your pencil and then rubbing over the pencil lines with a knuckle to soften. The pencil lines are hard edged by default. If working digitally, use a soft-edged airbrush and a hard-edged airbrush at a low opacity.

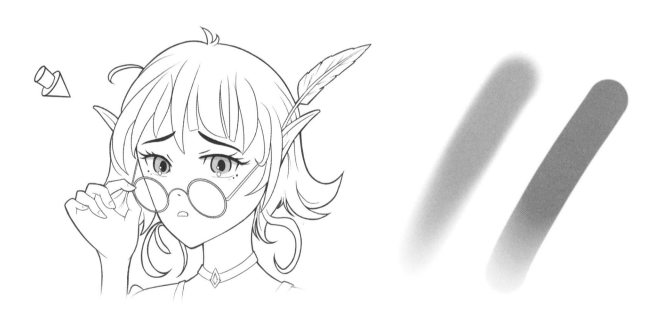

STEP 2: PLACE SOFT SHADOWS

Our next step is placing soft shadows around the edges of each major object on the character. In this example, soft shadows are placed along the edges of the hair and hair strands, the skin, the hand, and the feather. Try to keep the outer edges of the drawing free from shadows bleeding out of the lines.

STEP 3: PLACE HARD SHADOWS

With the soft shadows in place, we can now focus on placing more detailed hard shadows. Think about places where you might see the darkest shadows on a character—places like the nostrils, corners of the eyes, inside the ears, and so forth. Also think about where you might see cast shadows, such as the head casting a shadow over the neck or floating pieces of hair casting shadows over the face. Using your light source as a guide, determine where these darkest areas are and gently shade them in using your hard edges.

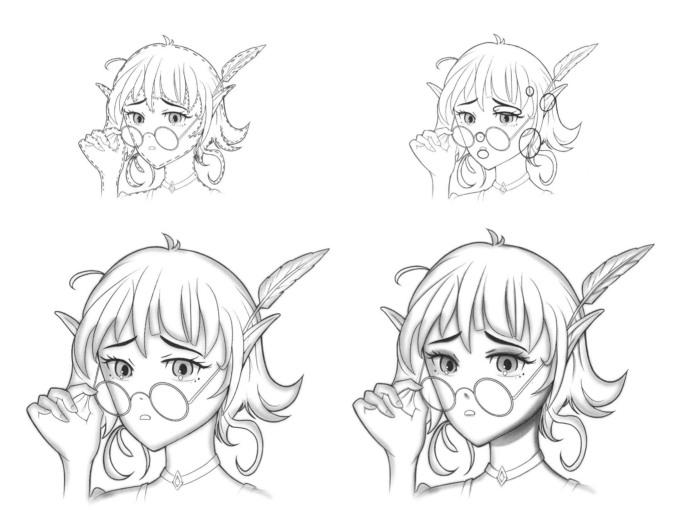

THE COMPLETED SOFT SHADING.

THE FINAL IMAGE HAS AN APPEALING BUT SIMPLE 3D LOOK.

AKARI THE SCHOOLGIRL

Akari is a classic manga schoolgirl character
that would be a great addition to any manga story.

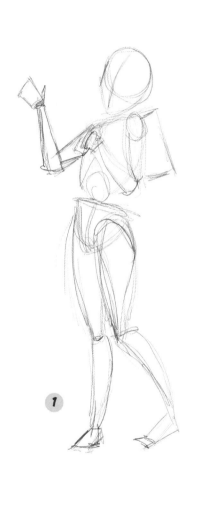

1

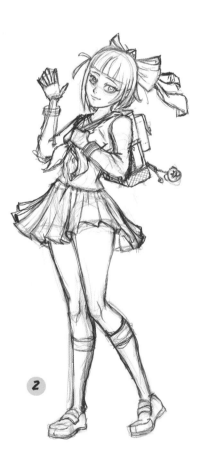

2

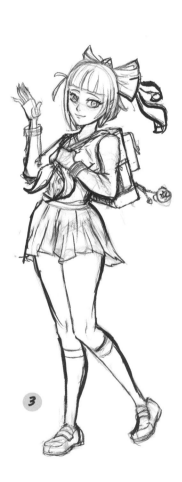

3

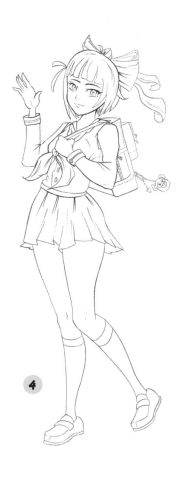

4

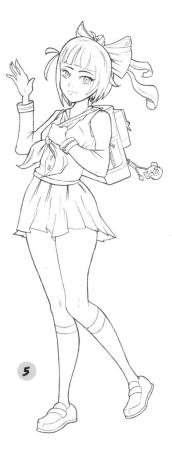

5

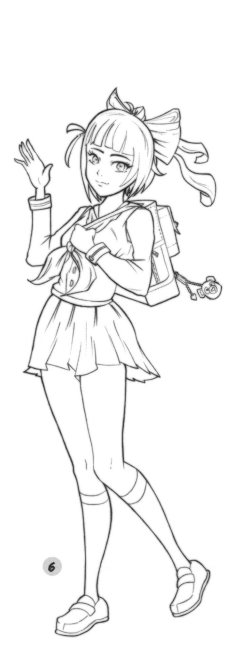

6

TIP: Don't feel like you need to be stuck to your initial rough plan—your character's pose, expression, and other elements can evolve as you move through the workflow of a piece.

SATCHIKO THE WITCH

No Halloween story is complete without a cute witch with a broomstick.
Add in seasonal props for some extra flare!

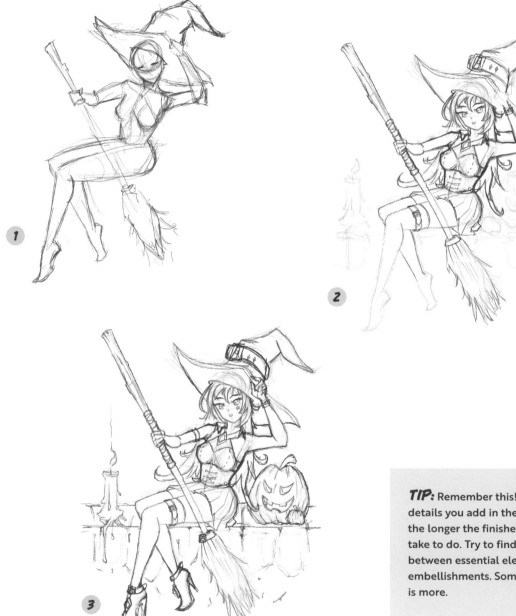

TIP: Remember this! The more details you add in the rough stage, the longer the finished drawing will take to do. Try to find a balance between essential elements and embellishments. Sometimes, less is more.

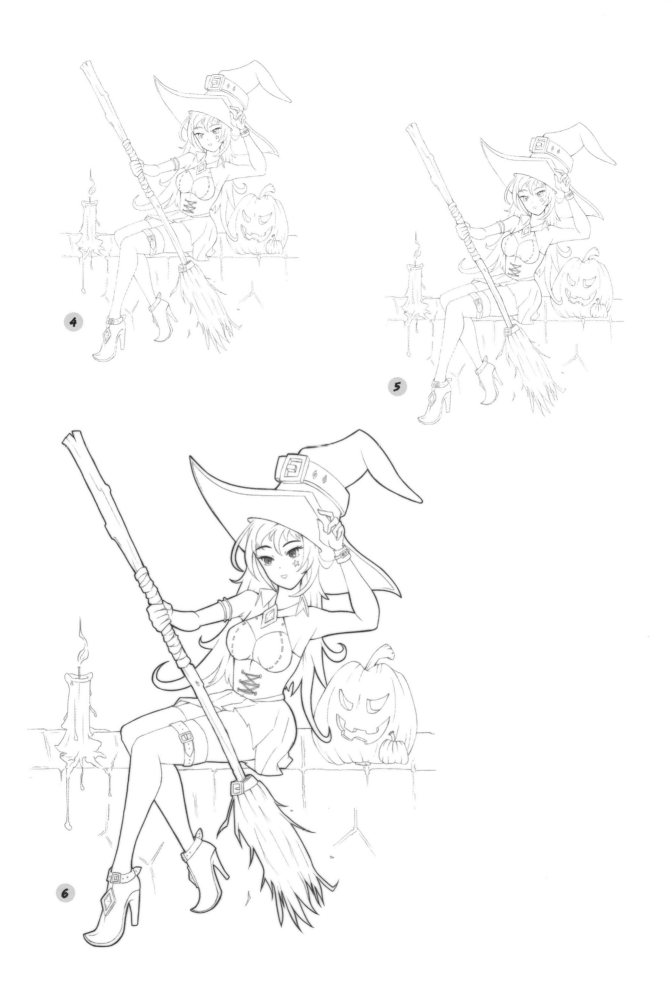

HINOTE THE CHIBI NINJA

An elite but cute ninja who leads his friends on daring adventures, this character can feature in any action-packed manga story.

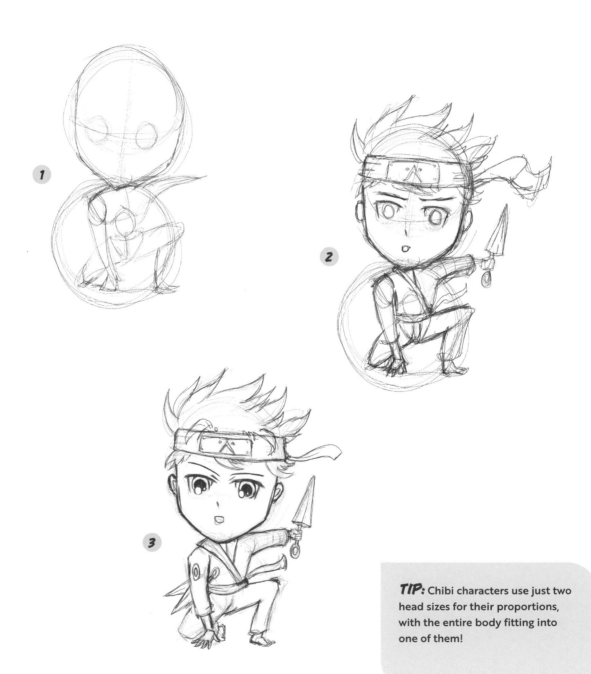

TIP: Chibi characters use just two head sizes for their proportions, with the entire body fitting into one of them!

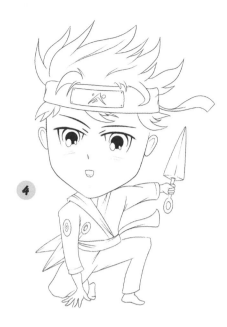

4

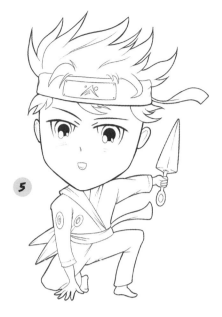

5

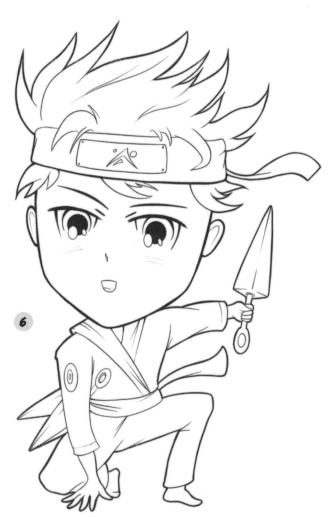

6

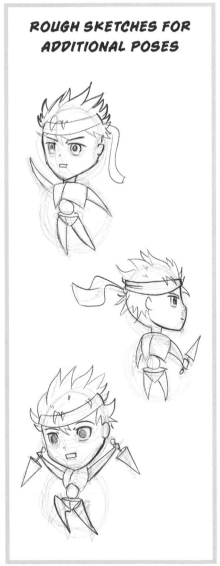

ROUGH SKETCHES FOR ADDITIONAL POSES

TRADITIONAL YUA

Yua loves going to traditional festivals and is the perfect addition to a story incorporating historical Japanese elements.

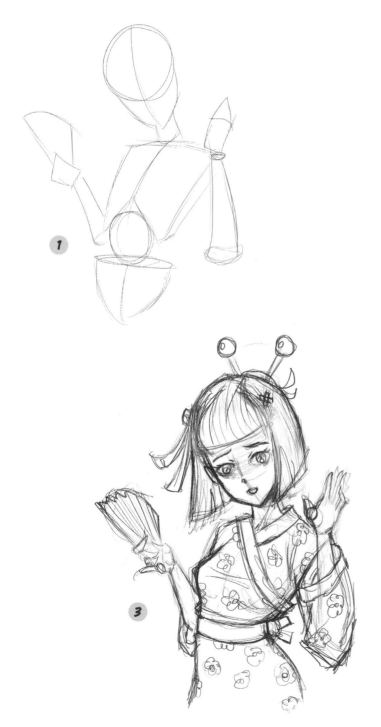

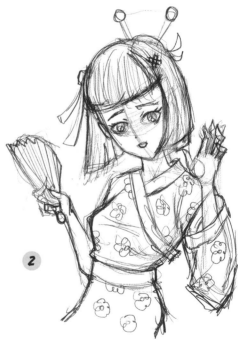

TIP: Adding a tilt to a character's head is a great way to easily add in some extra dynamism.

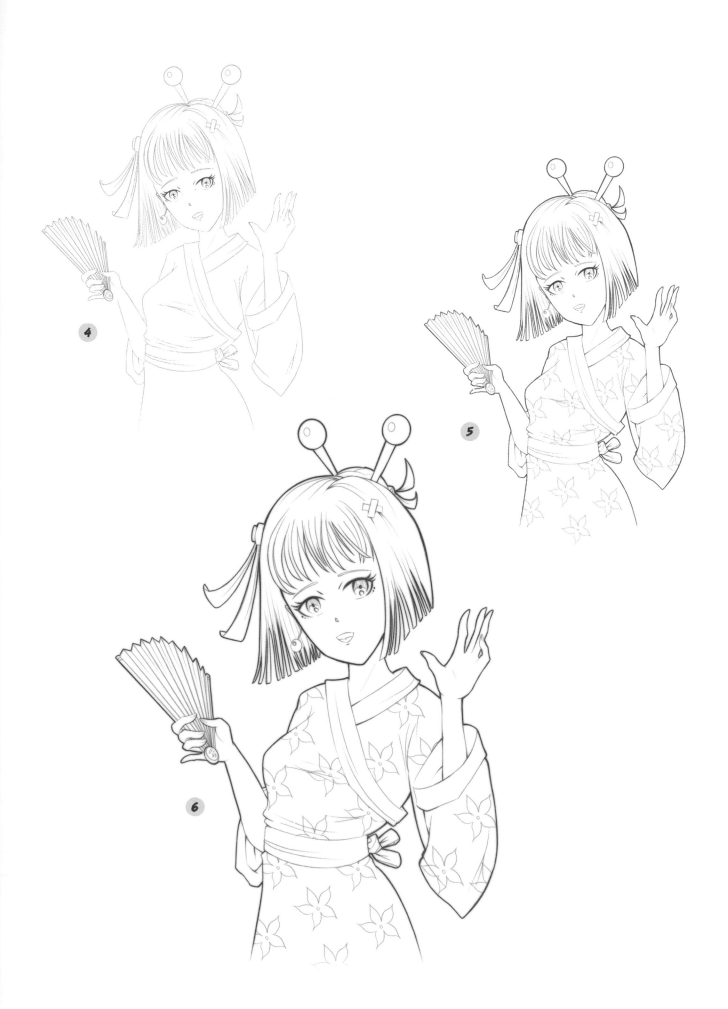

MISAKI THE FANTASY FLOWER GIRL

Misaki is a rose-laden fantasy girl in a modern manga fairy tale.

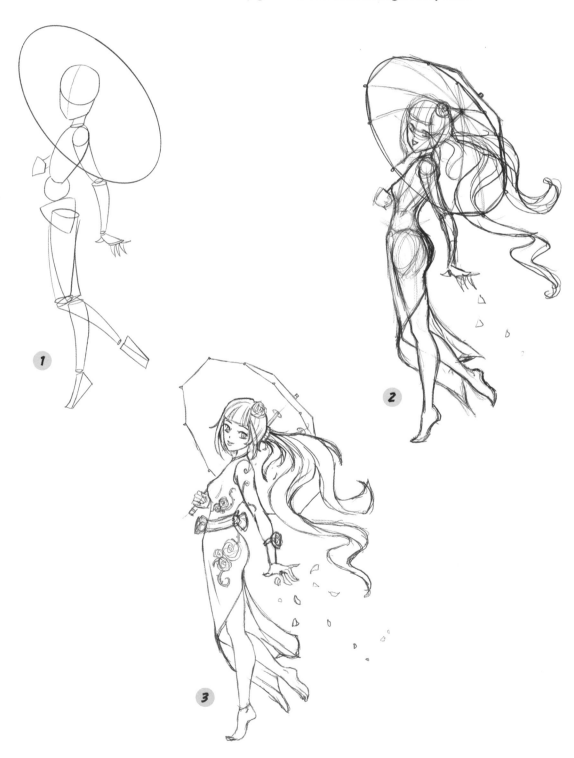

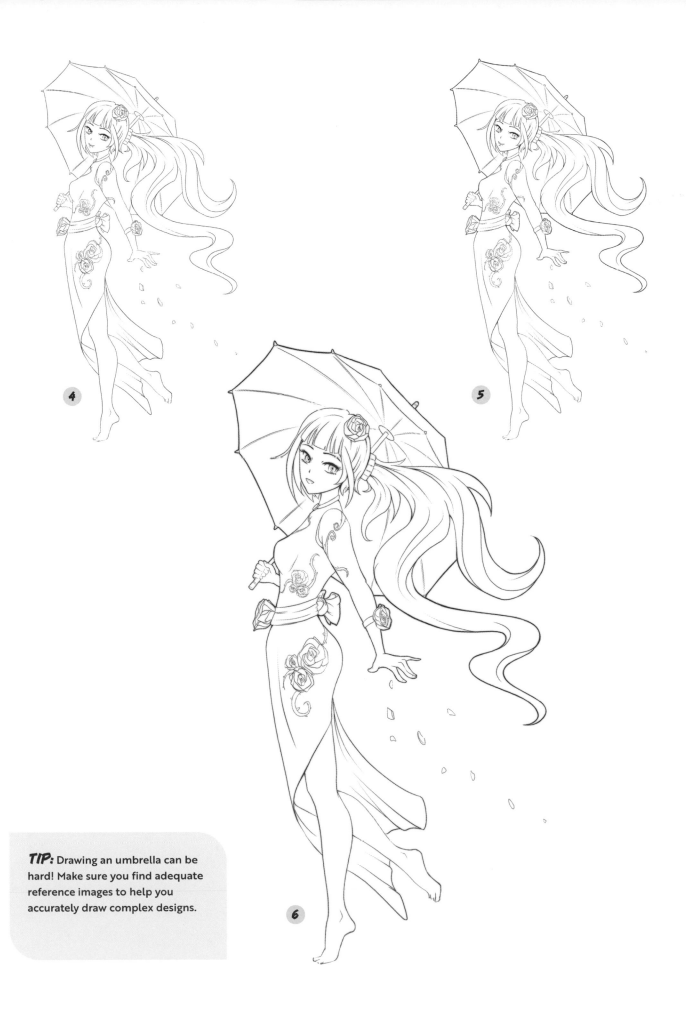

4

5

6

TIP: Drawing an umbrella can be hard! Make sure you find adequate reference images to help you accurately draw complex designs.

TECH KNIGHT TOUMA

Touma is a chivalrous, high-tech knight from a futuristic online role-playing game world.

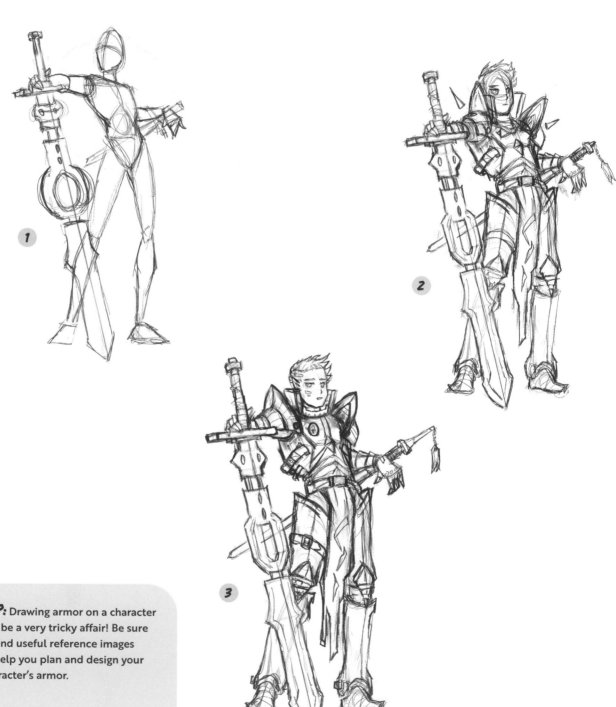

TIP: Drawing armor on a character can be a very tricky affair! Be sure to find useful reference images to help you plan and design your character's armor.

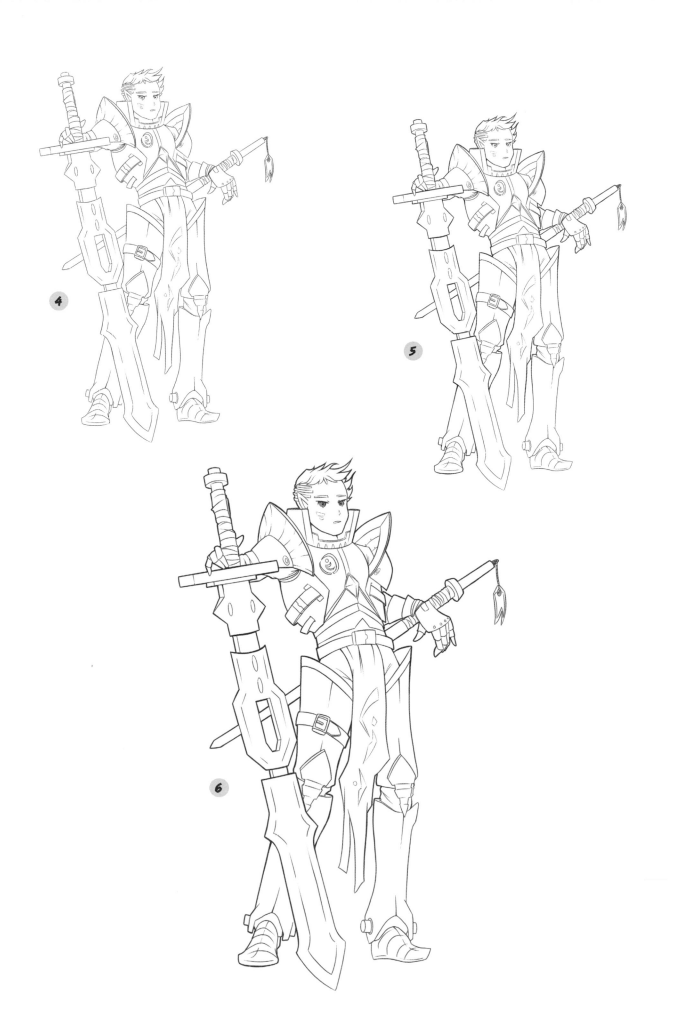

FLOWERING SATOMI

A flowering fantasy fairy, Satomi is perfect
as a side character in a medieval manga tale.

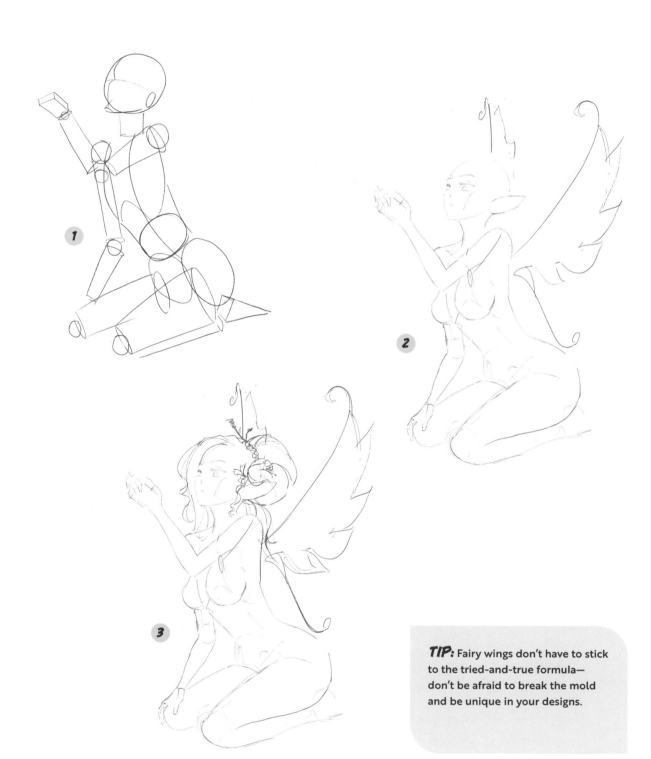

TIP: Fairy wings don't have to stick
to the tried-and-true formula—
don't be afraid to break the mold
and be unique in your designs.

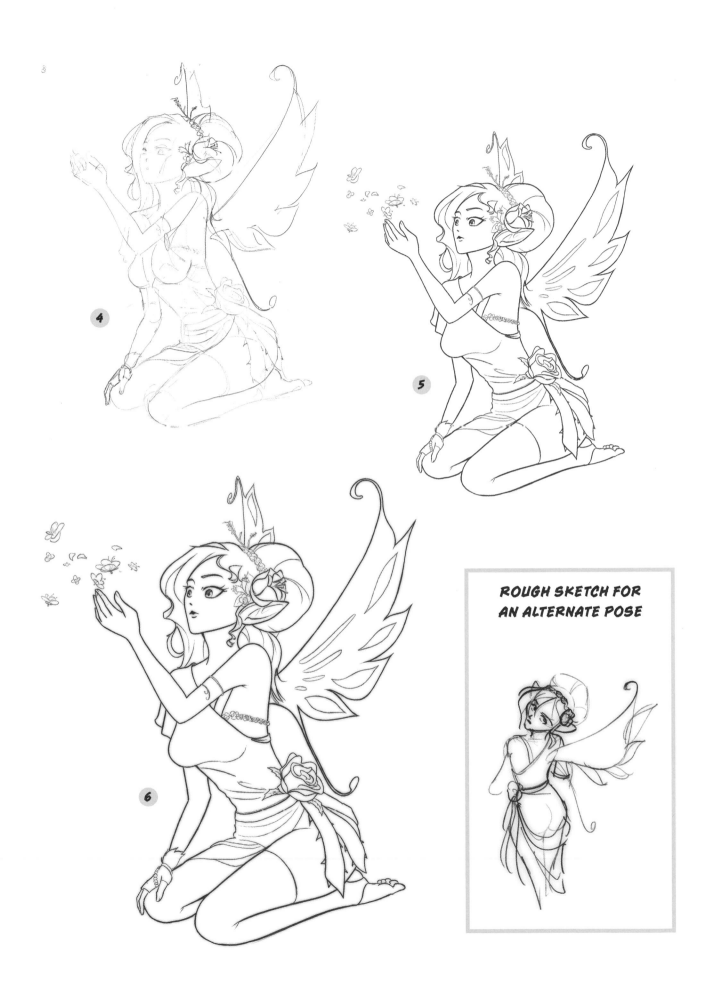

ROUGH SKETCH FOR AN ALTERNATE POSE

KAIRI THE MERMAID

Pirates, urchins, and mermaids all make for a great
imaginative manga story on the seven seas!

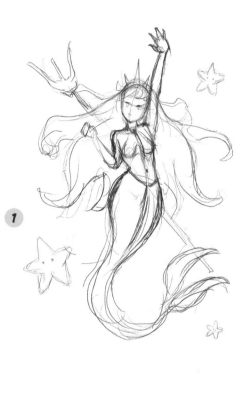

1

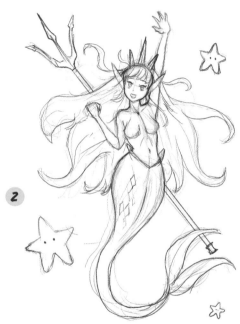

2

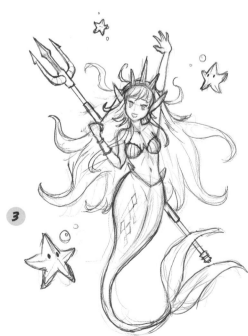

3

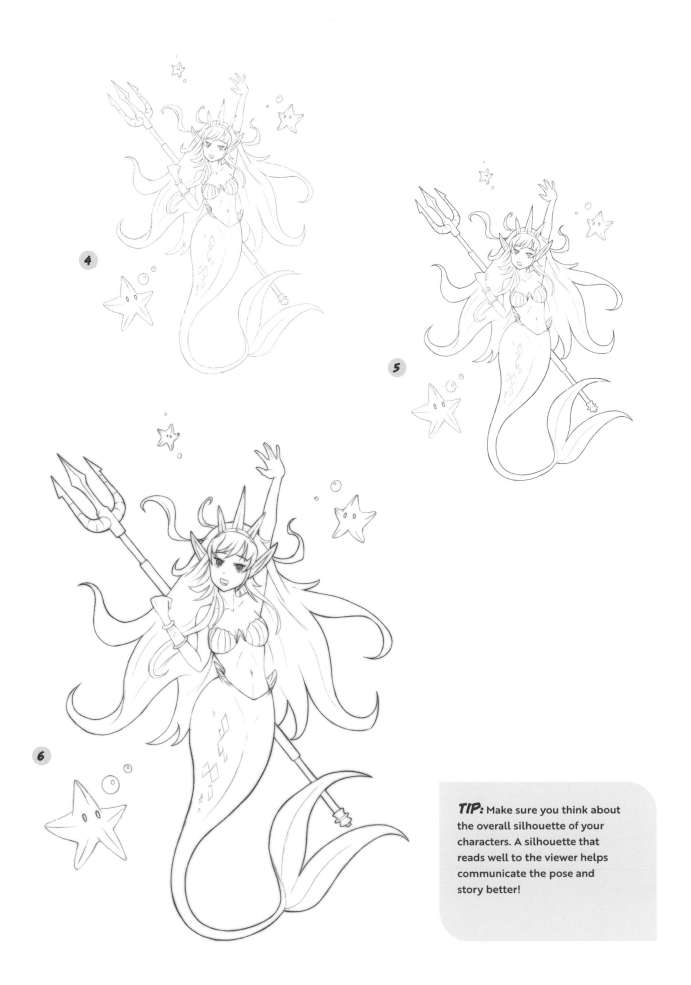

SPRINTING KAIDA

Kaida is a schoolgirl character with a penchant for imagination,
and as you can see by her costume, she loves pretending to be a pirate.

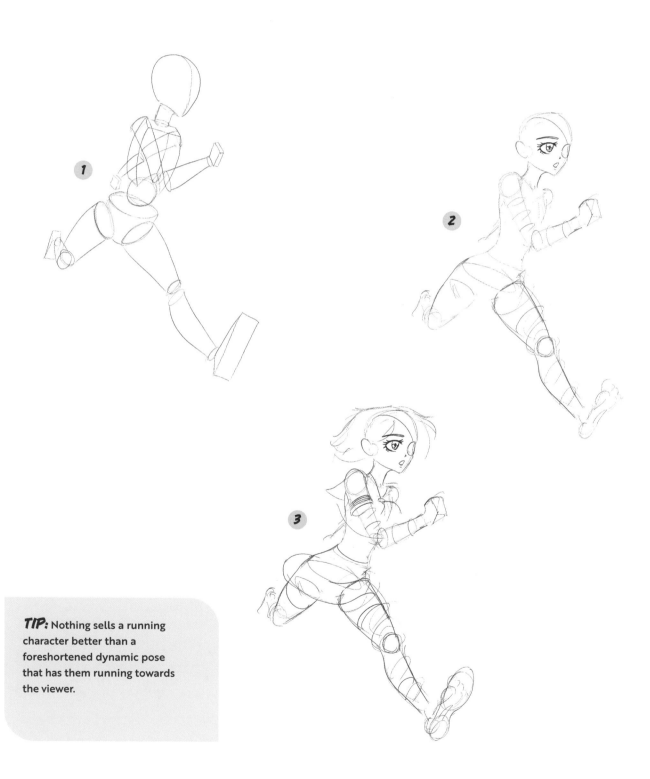

TIP: Nothing sells a running
character better than a
foreshortened dynamic pose
that has them running towards
the viewer.

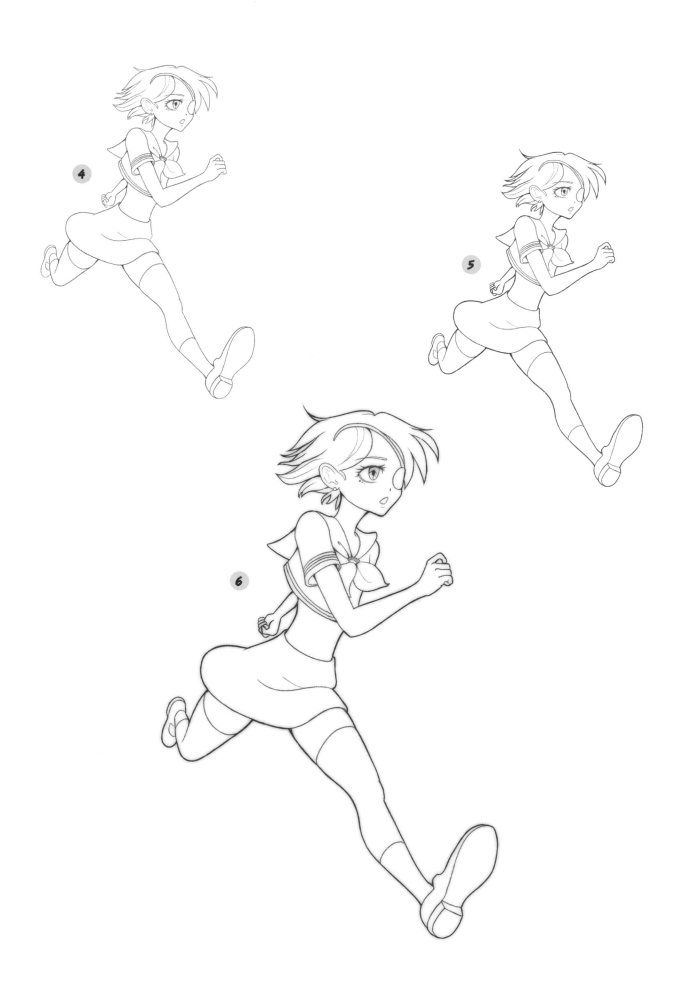

SAMURAI RAIDEN

Raiden is a feared Samurai warrior whose highest ideal is to fight with honor.

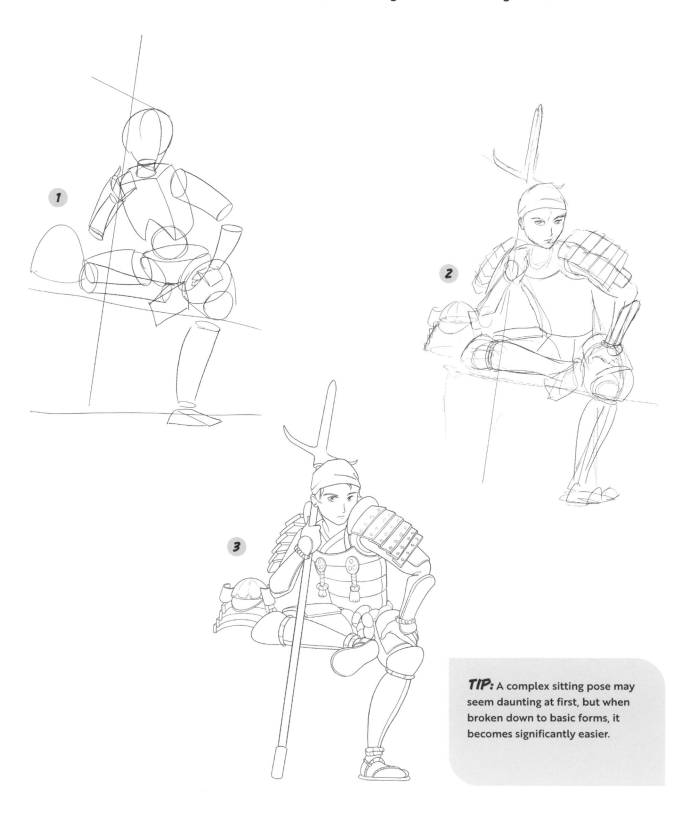

TIP: A complex sitting pose may seem daunting at first, but when broken down to basic forms, it becomes significantly easier.

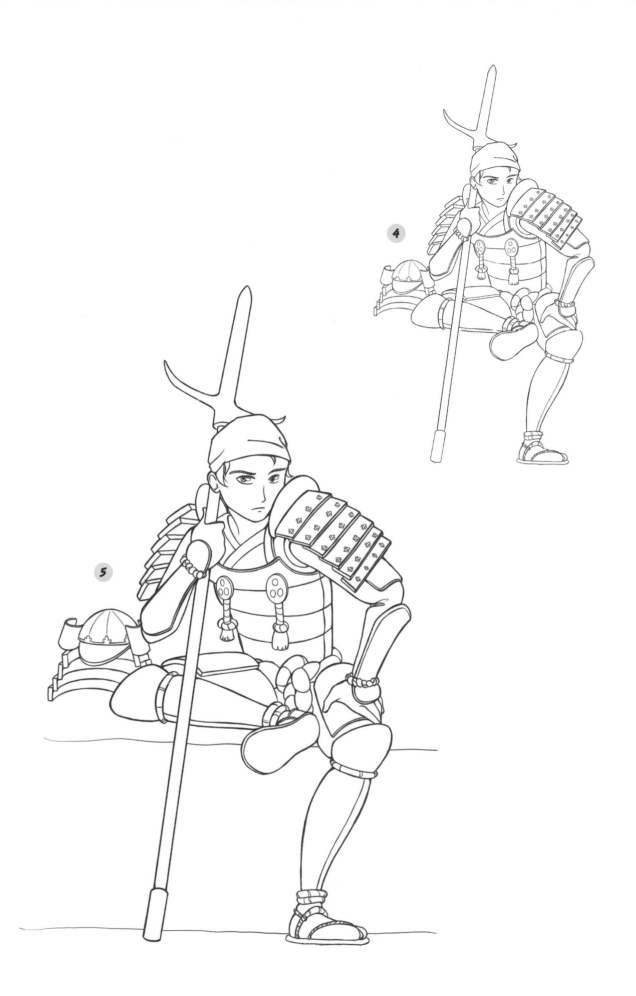

ICHIGO THE MUSIC FAN

Ichigo loves music more than anything else and is a perfect fit for a cute musical manga story.

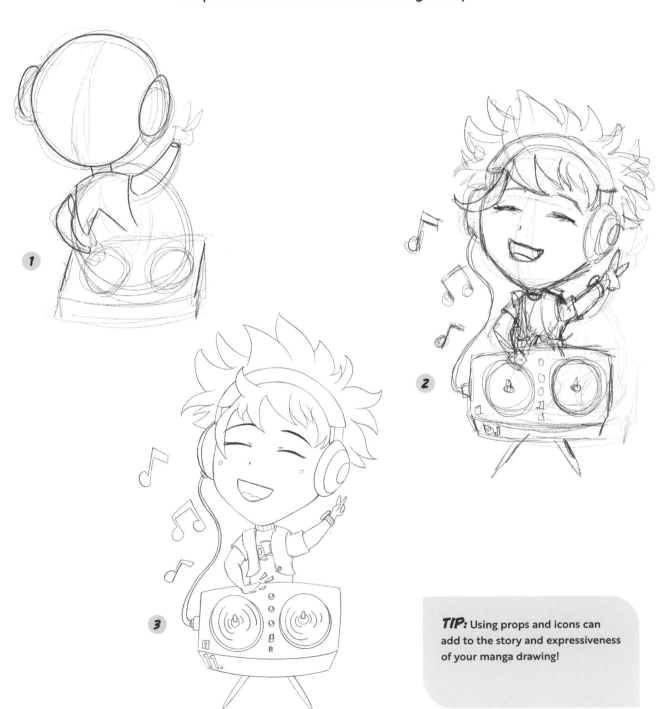

TIP: Using props and icons can add to the story and expressiveness of your manga drawing!

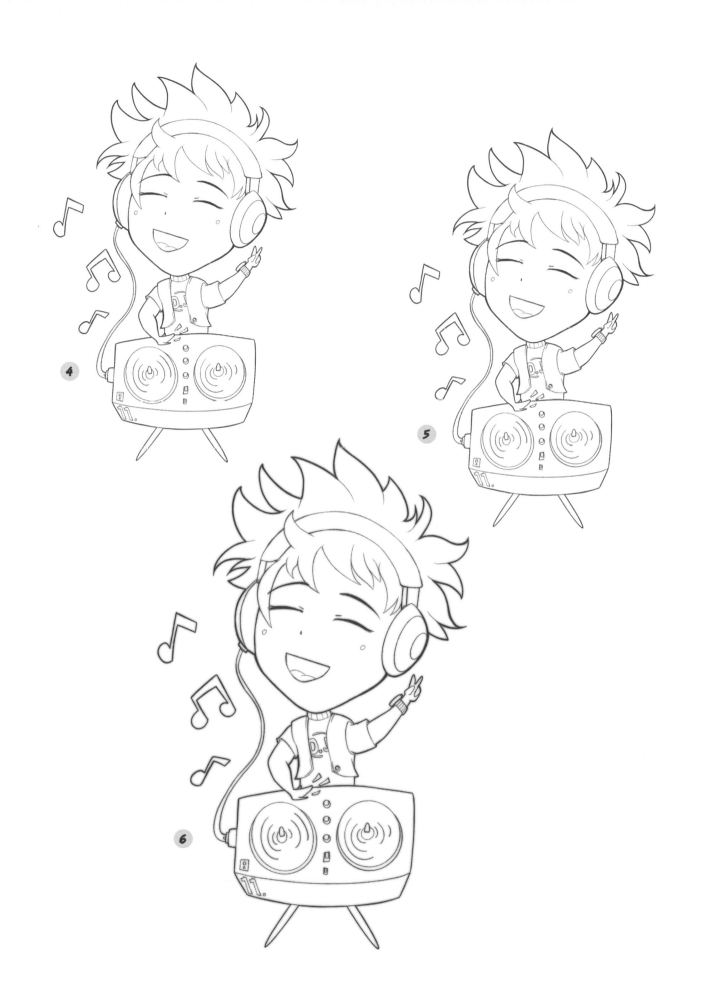

CANDY KAORI

Kaori adores all kinds of candy, and sweets make
the perfect addition to her modern apparel.

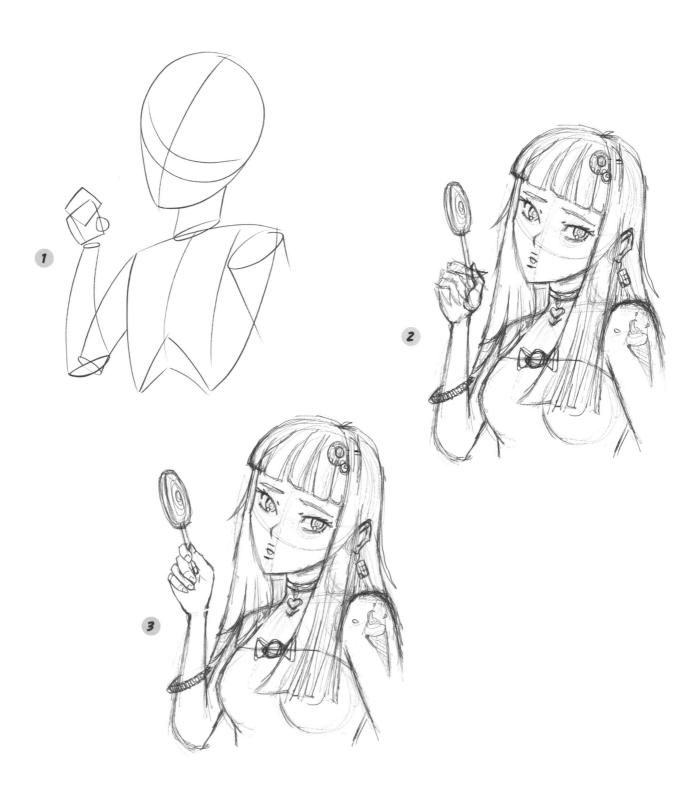

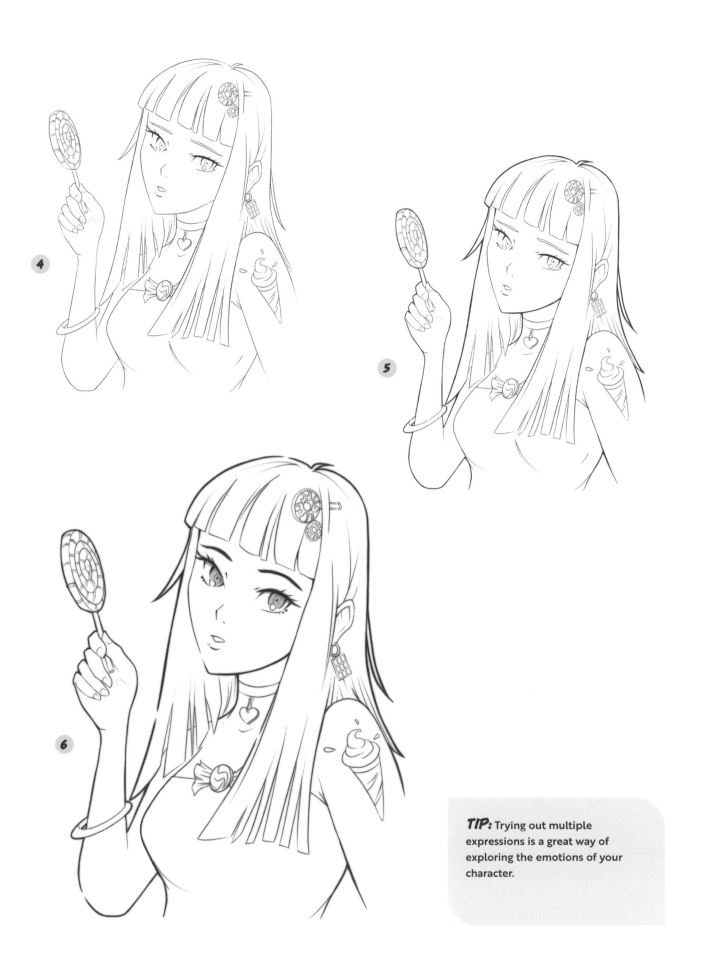

RIKU AND REN

No story is complete without a best-friend karate duo
to add intrigue, action, and laughter to a story.

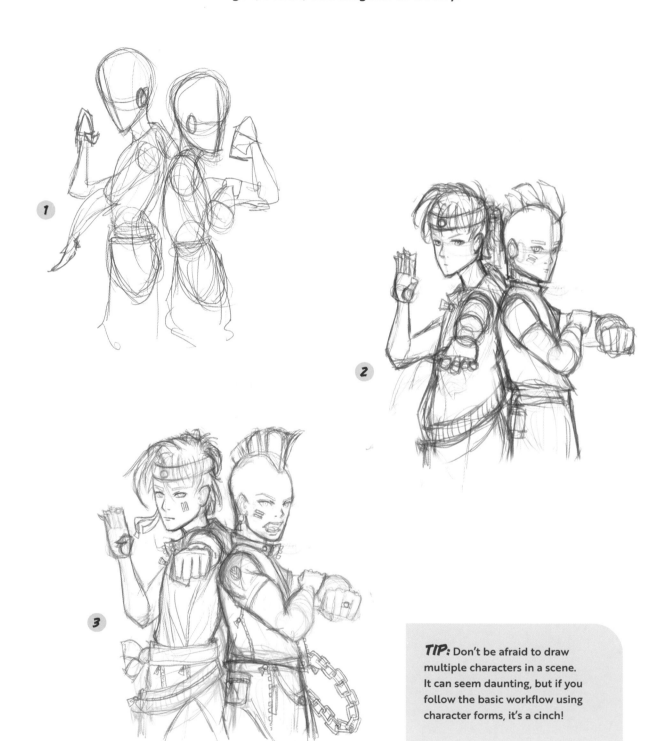

TIP: Don't be afraid to draw
multiple characters in a scene.
It can seem daunting, but if you
follow the basic workflow using
character forms, it's a cinch!

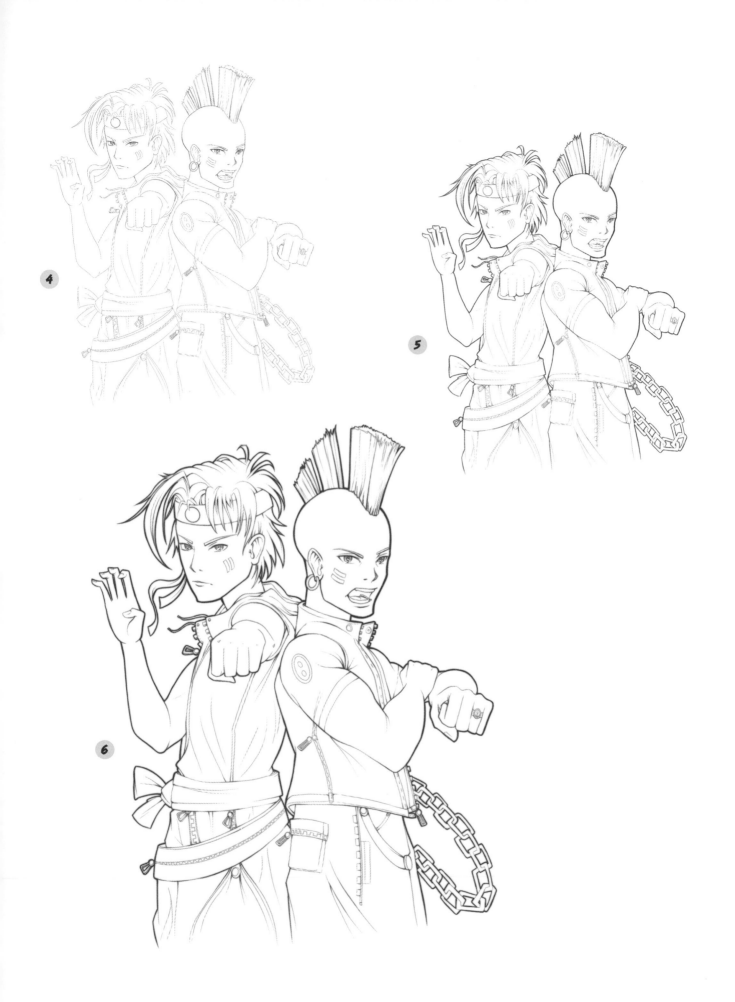

TICK-TOCK MOMOKO

Tick-Tock Momoko fits right into a whimsical fantasy setting where worlds and time collide.

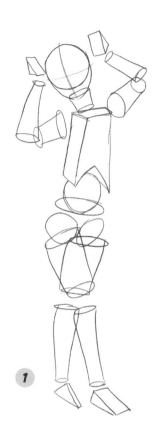

1

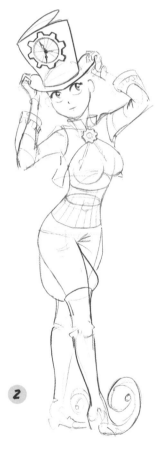

2

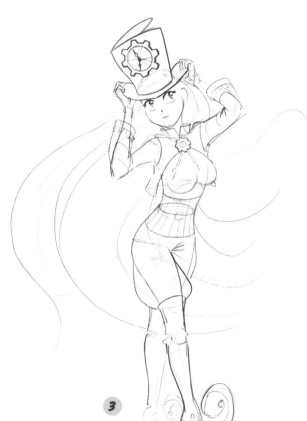

3

TIP: Adding in flourishes and embellishments to clothing can really enhance the fantasy feeling of the character.

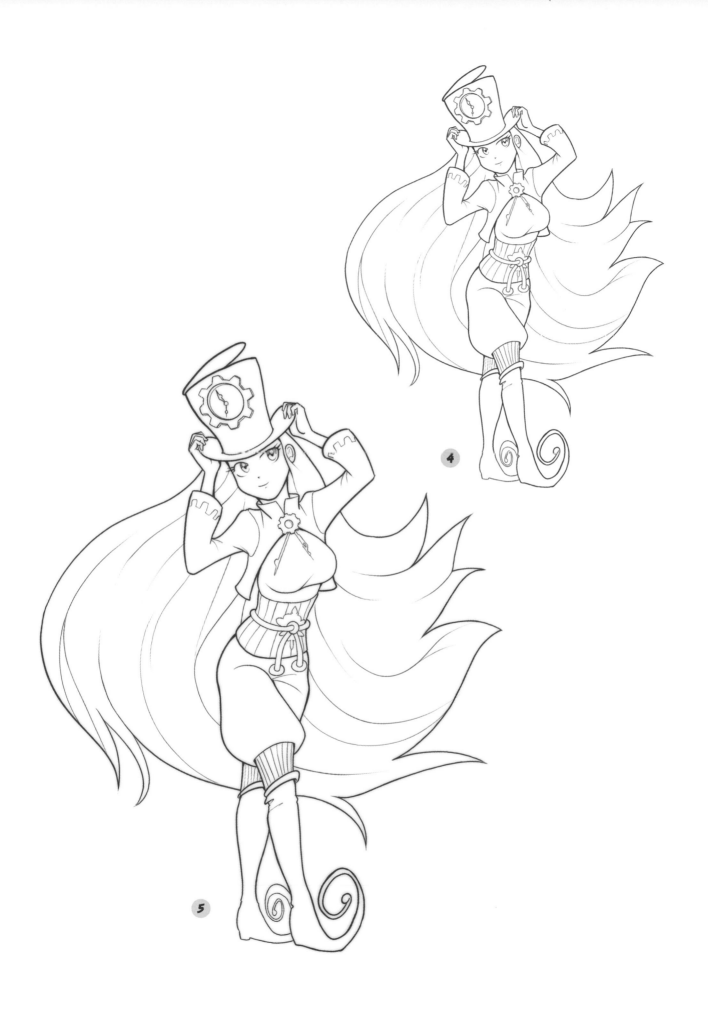

NYOKO OF MIZU

Nyoko is a water goddess character perfectly suited for a fantasy manga with elemental superpowers as a core story element.

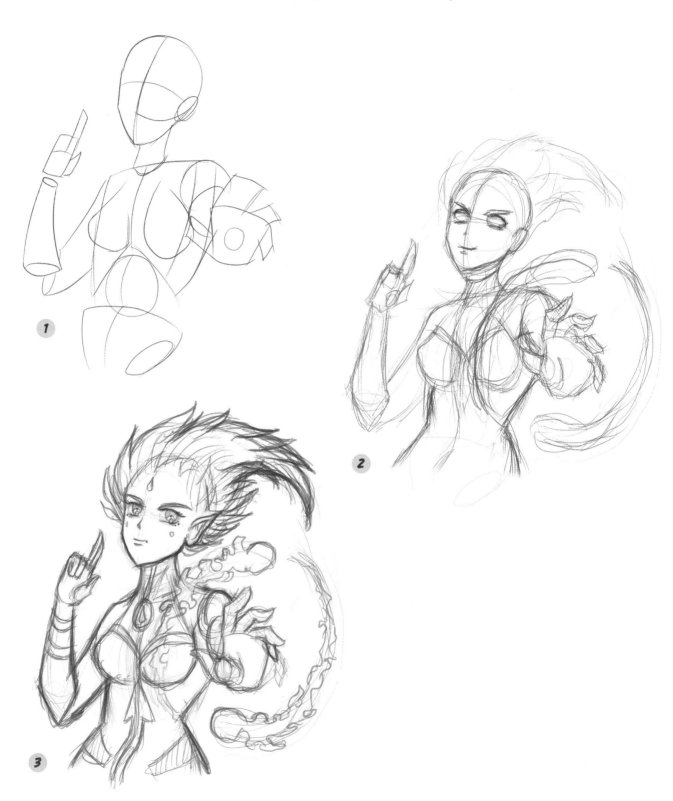

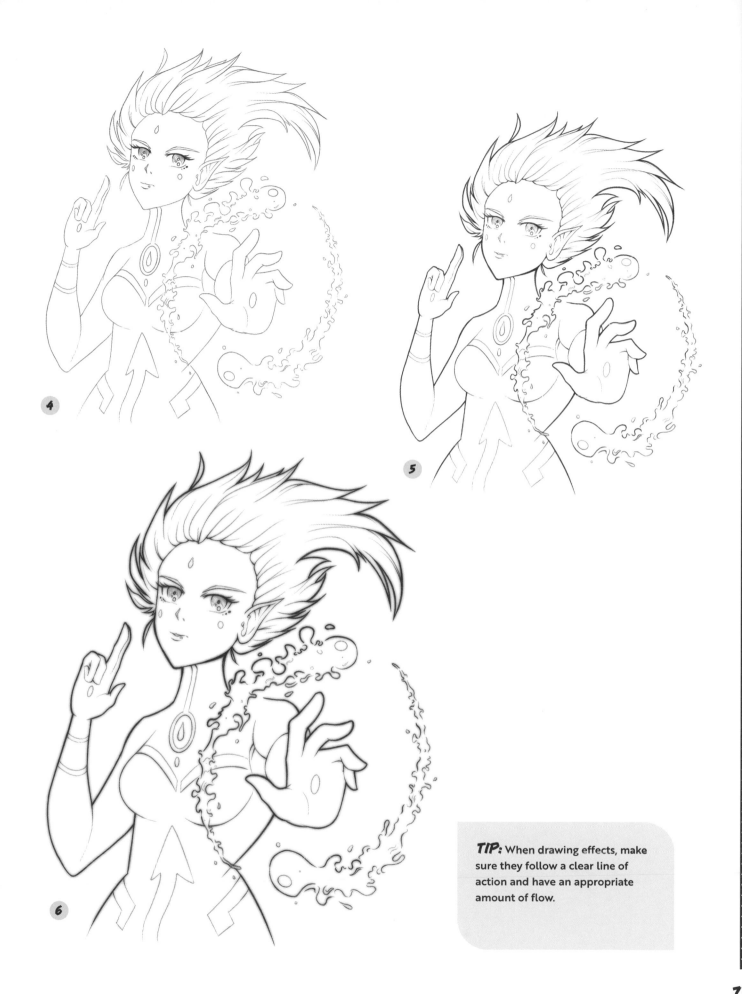

TIP: When drawing effects, make sure they follow a clear line of action and have an appropriate amount of flow.

HIROKO THE CHEERLEADER

Hiroko cheers for her school's team with all her spirit; she's a unique character in a school-story manga.

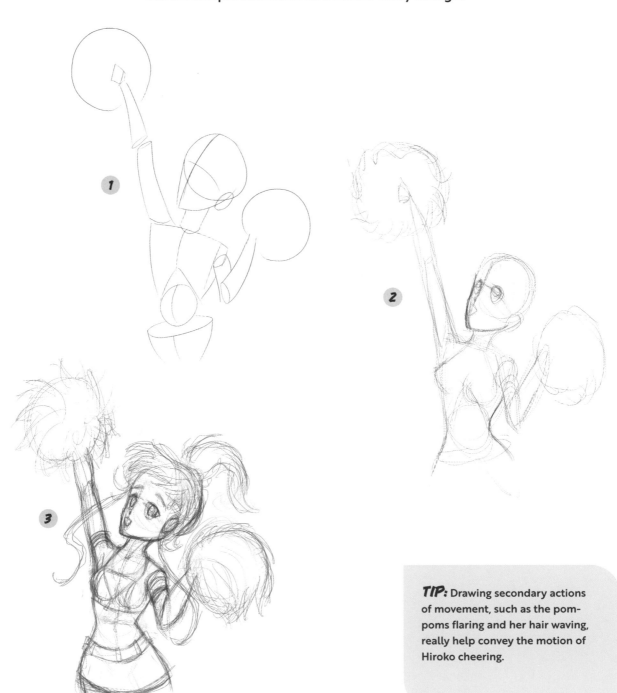

TIP: Drawing secondary actions of movement, such as the pompoms flaring and her hair waving, really help convey the motion of Hiroko cheering.

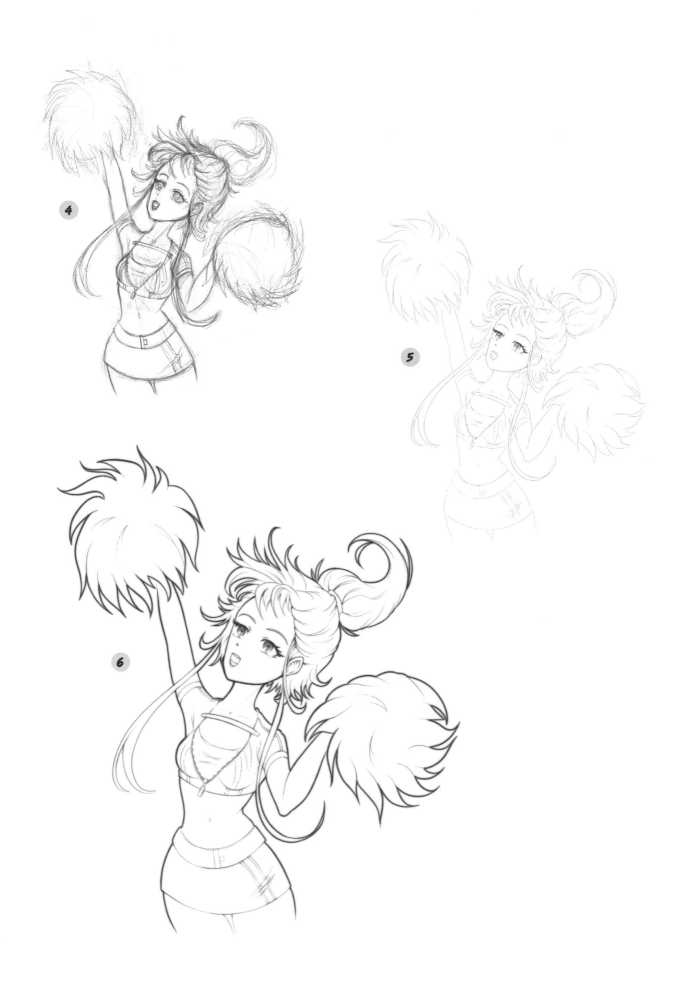

CHIBI BASKETBALL PLAYER KEI

Shooting hoops and winning games is all in a day's work for Kei,
the star player of his basketball team.

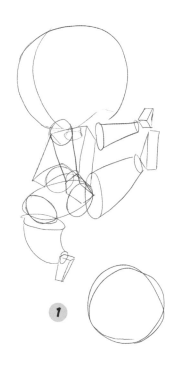

1

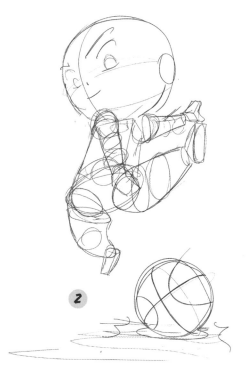

2

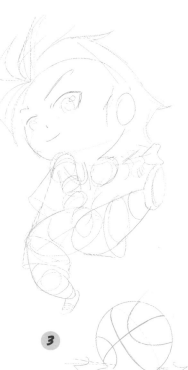

3

TIP: Chibi bodies are easier to draw than anatomically realistic ones, so use that to your advantage and create dynamic angles and poses, such as Kei energetically showing off his dribbling skills.

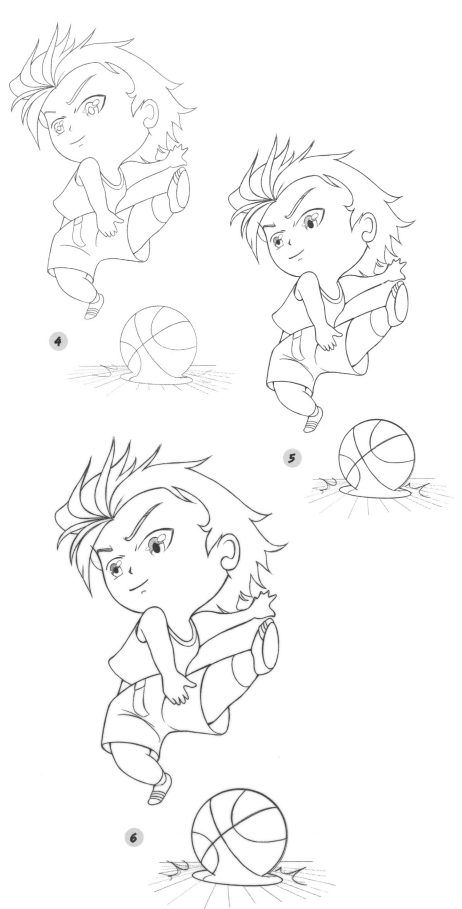

4

5

6

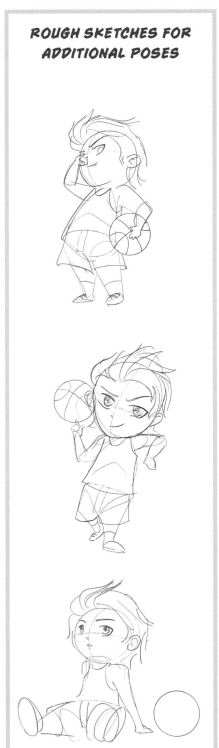

SPORTY SUZUKI

Every big sports game has big fans, and Suzuki is one of the biggest!

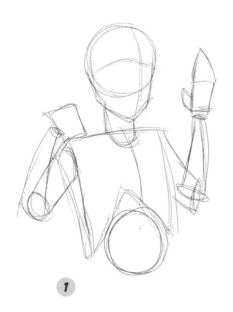

1

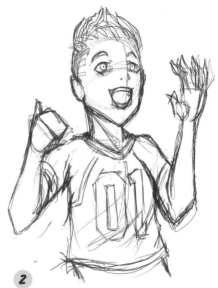

2

3

TIP: When drawing facial expressions, try to grasp the emotion with simple eye, eyebrow, and mouth shapes first, before adding in the details.

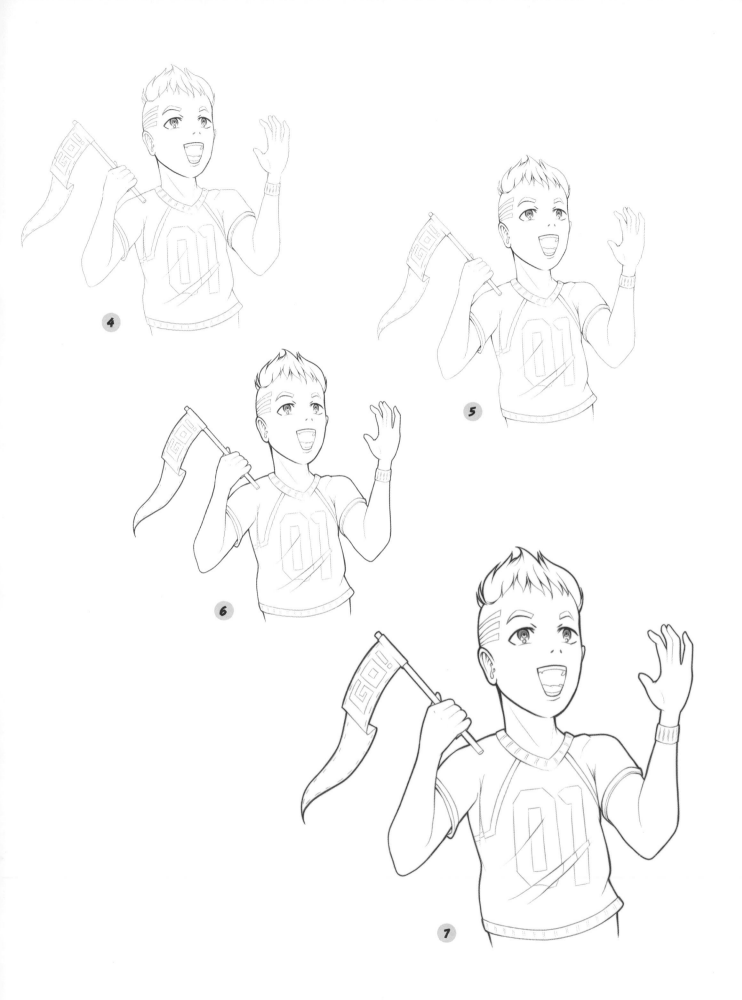

YUKA THE PENSIVE ELF

Yuka is a thoughtful elf that considers every action she takes carefully.

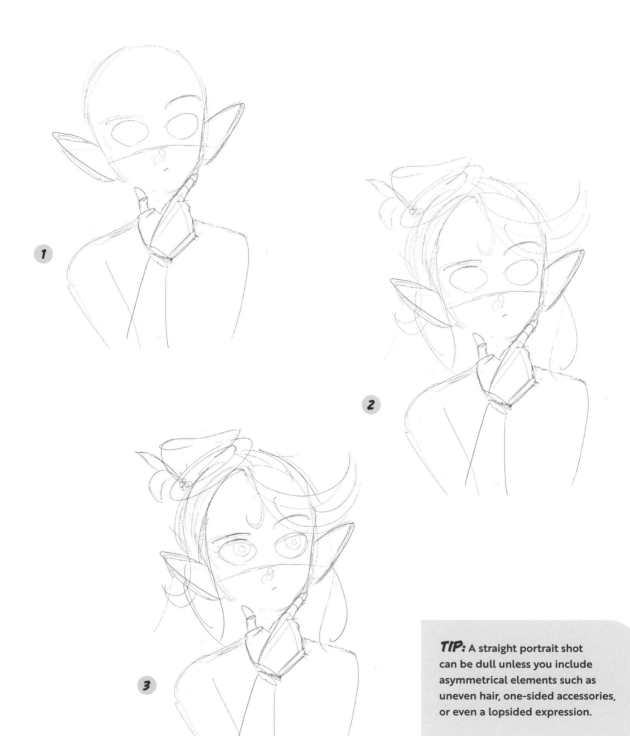

TIP: A straight portrait shot can be dull unless you include asymmetrical elements such as uneven hair, one-sided accessories, or even a lopsided expression.

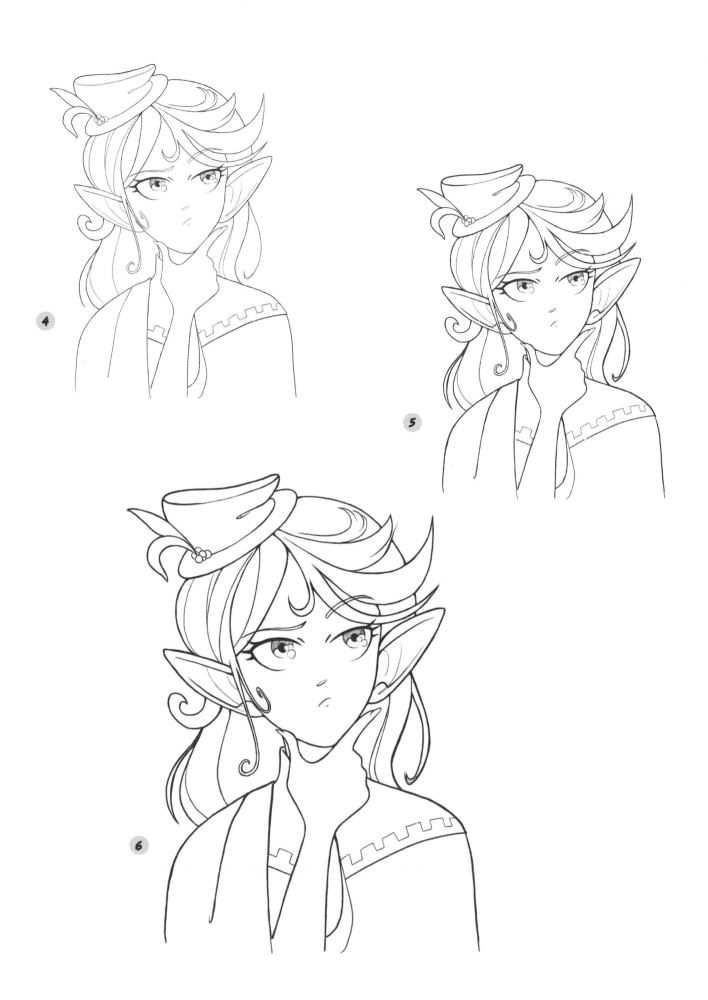

OHTA AND NISHI, WOMEN WIZARDS

These two friends sneakily grow their magic skills
as they adventure in the wizarding world of wands.

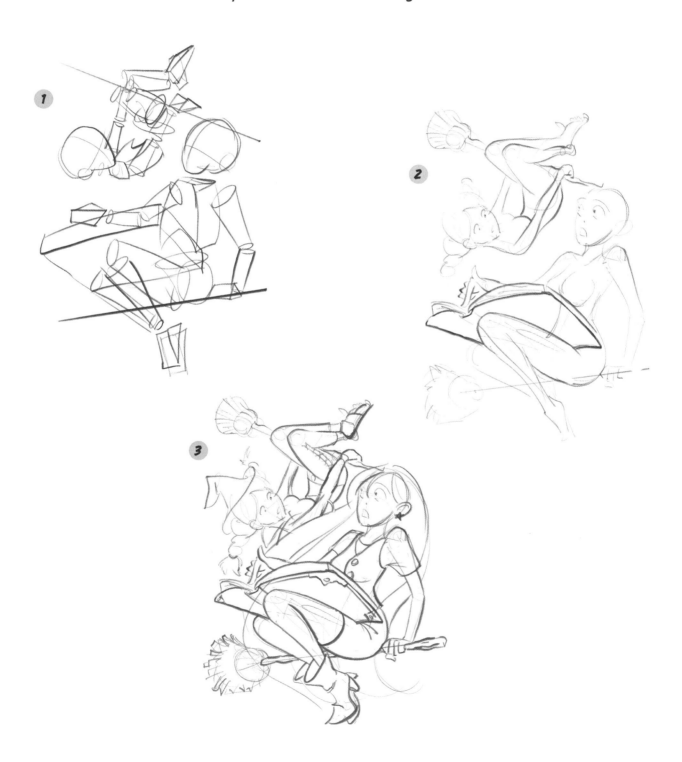

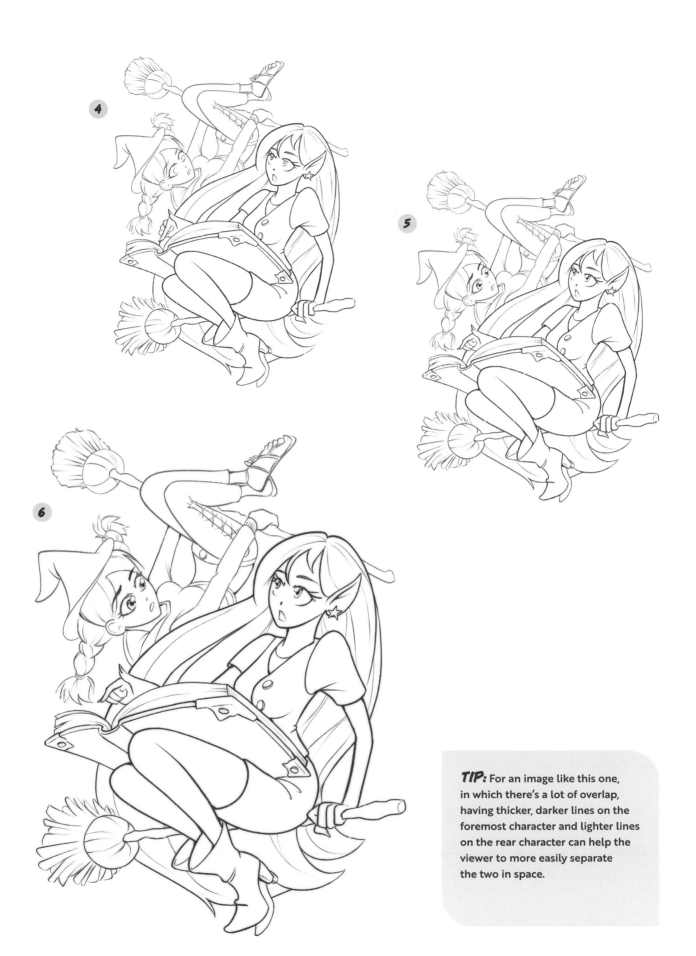

TIP: For an image like this one, in which there's a lot of overlap, having thicker, darker lines on the foremost character and lighter lines on the rear character can help the viewer to more easily separate the two in space.

KAYDA AND THE ROBOTS

A cute heroine and her robot sidekicks are a great addition to a science fiction manga story.

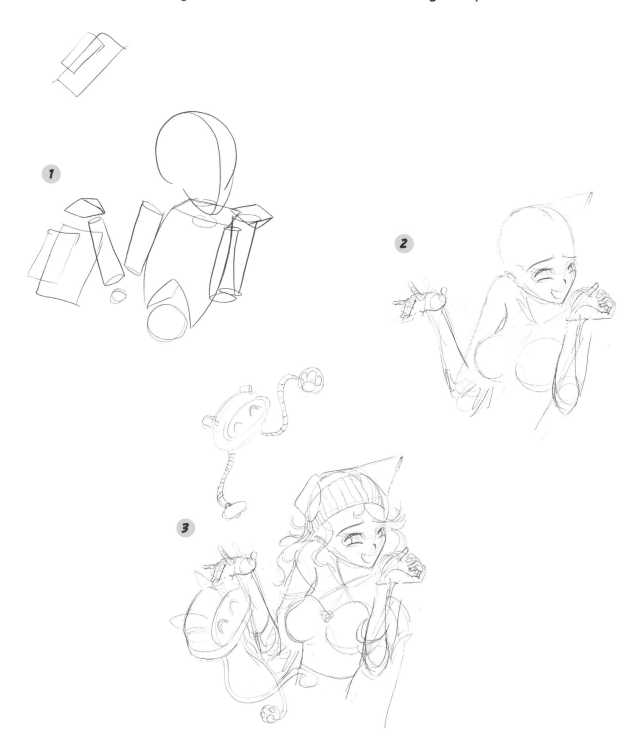

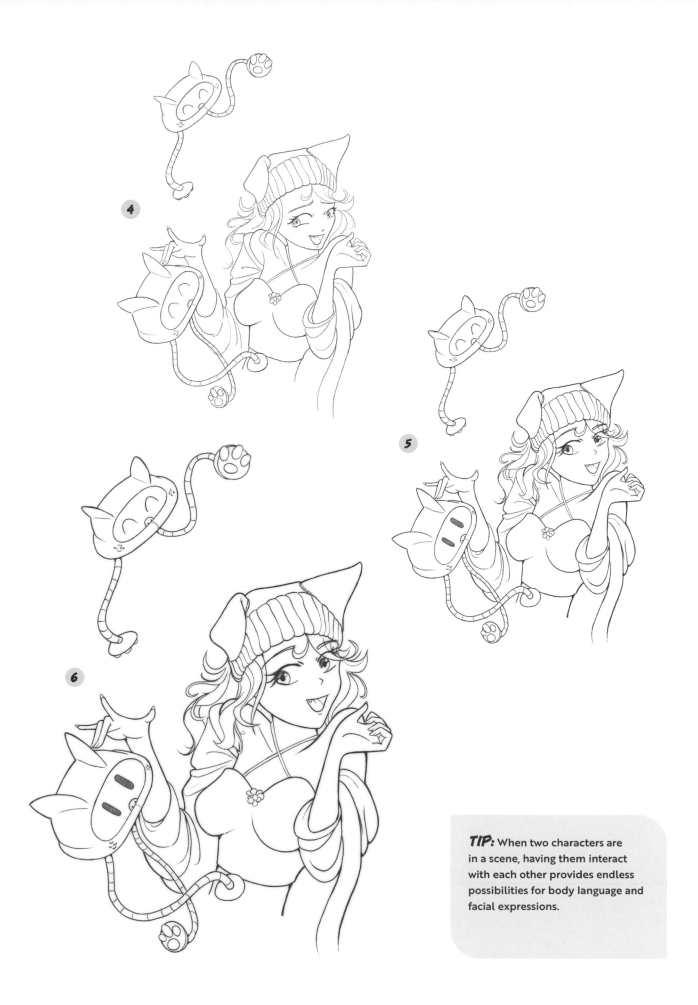

TIP: When two characters are in a scene, having them interact with each other provides endless possibilities for body language and facial expressions.

COOL SANA

Is she just a finely dressed character, a secret agent,
or an enemy spy engaging in espionage?

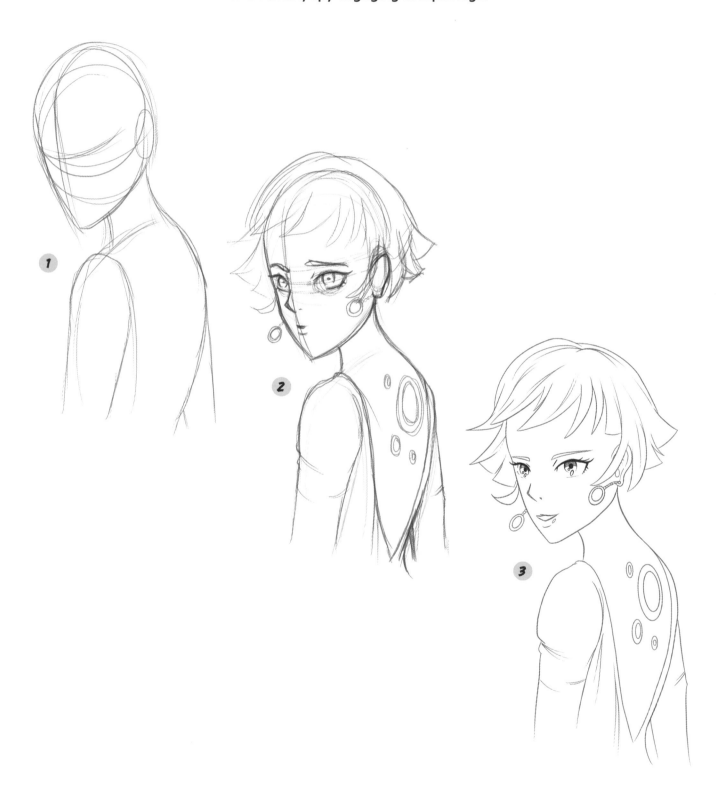

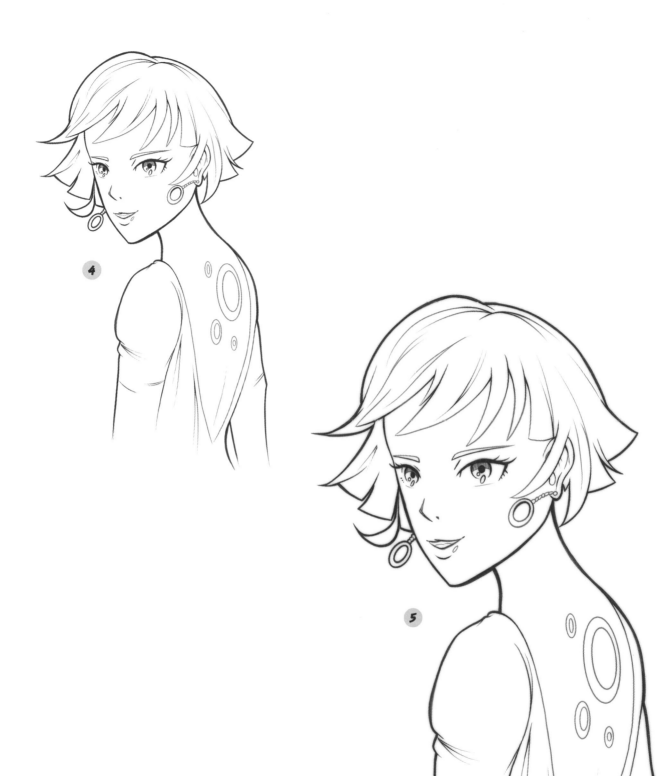

TIP: It's easy to fall into the trap of drawing the same pose over and over, so consider different ways to showcase your characters, such as a classic over-the-shoulder pose.

KIOKO AT THE OFFICE

Many manga are present day slice-of-life stories,
and the studious Kioko would suit any modern story.

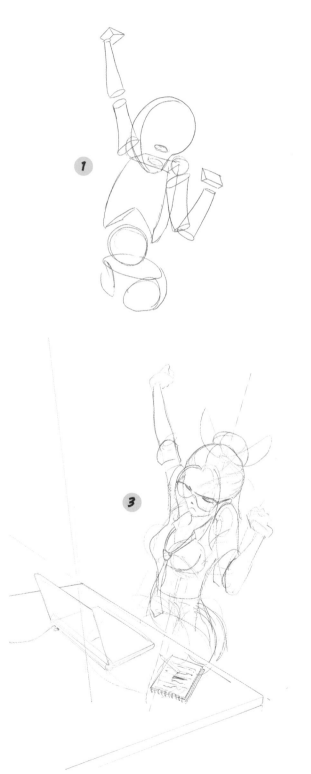

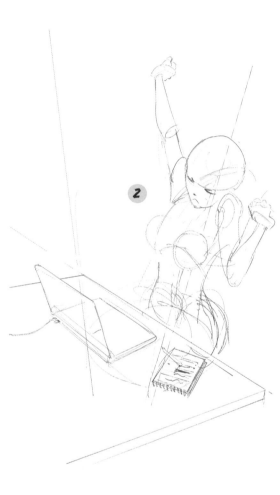

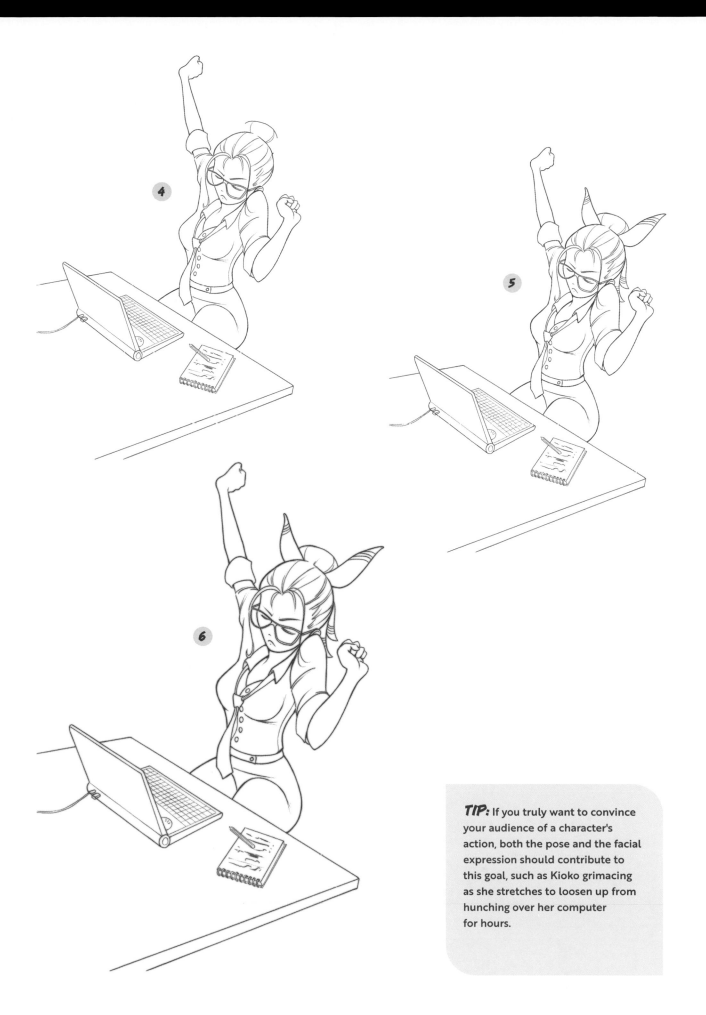

MAEKO THE WISE ELF

This cute, well-read elf would be a great addition to a fantasy manga story.

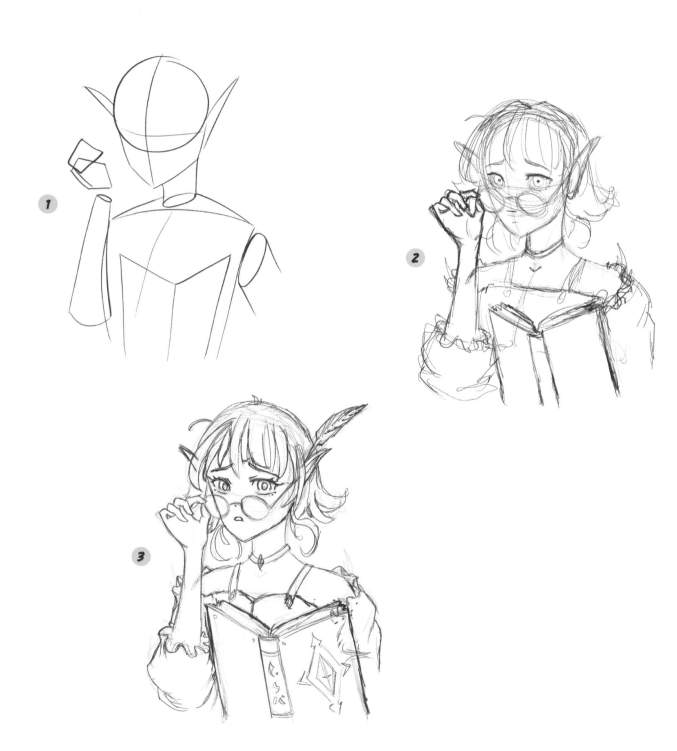

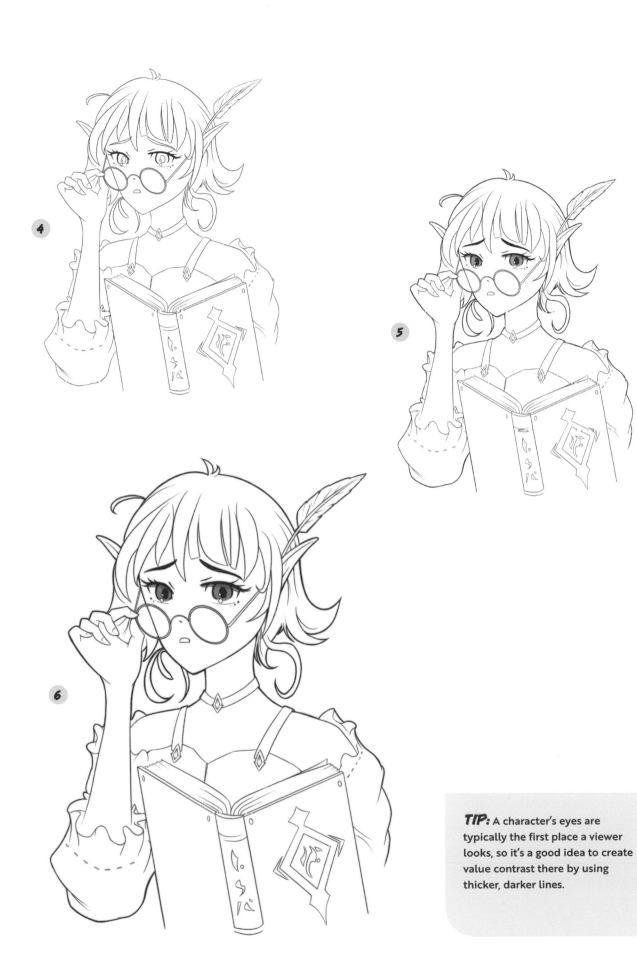

TIP: A character's eyes are typically the first place a viewer looks, so it's a good idea to create value contrast there by using thicker, darker lines.

HARUTO AND HONOKA ON THE TOWN

A couple out shopping on a sunny day would be a great feature in a classic romantic manga story.

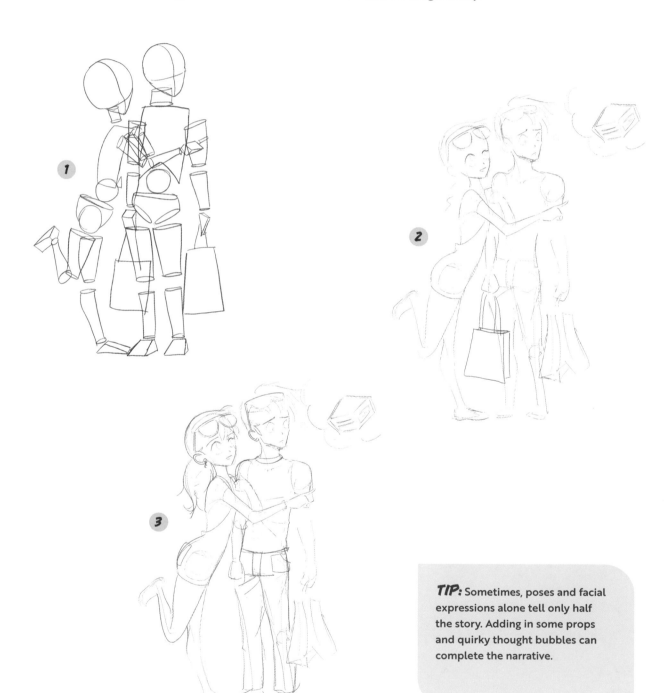

TIP: Sometimes, poses and facial expressions alone tell only half the story. Adding in some props and quirky thought bubbles can complete the narrative.

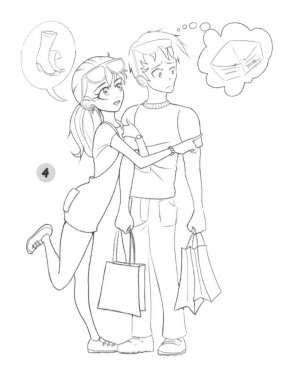

4

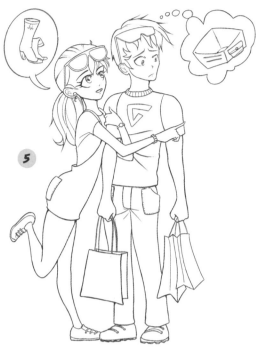

5

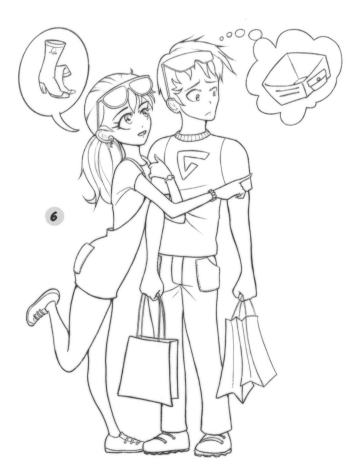

6

ROUGH SKETCHES FOR
ALTERNATE EXPRESSIONS AND
THOUGHT BUBBLE CONTENT

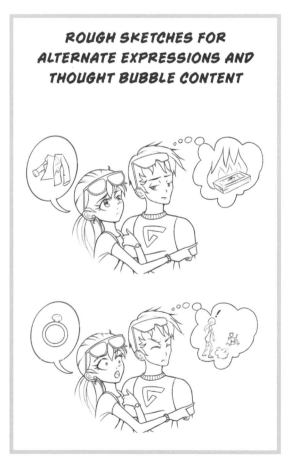

WATER WARRIOR AKIARA

Some people play with water guns for fun, but Akiara uses his water gun for sport and takes his hobby extremely seriously!

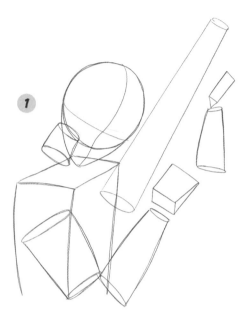

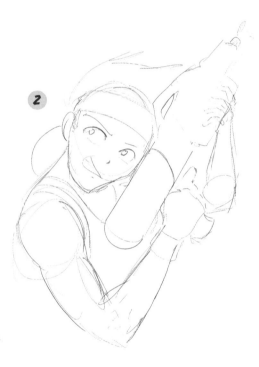

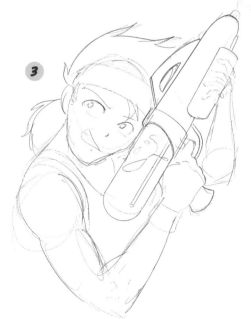

TIP: Reference can be invaluable when drawing characters holding props, but another approach is to draw the prop before the arms and hands, after which you can draw the arms and hands to correctly connect with it.

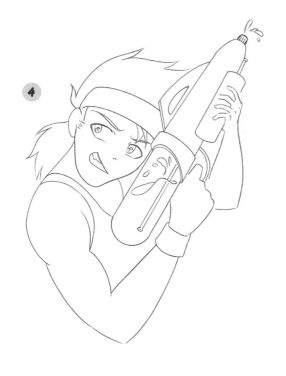

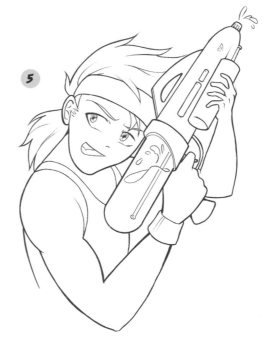

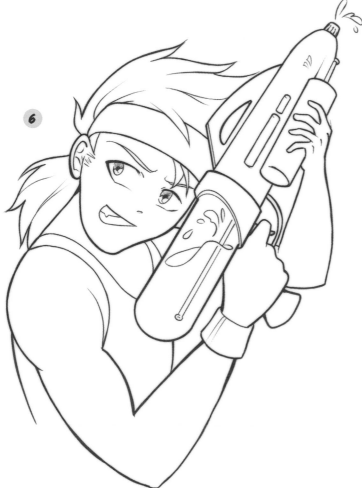

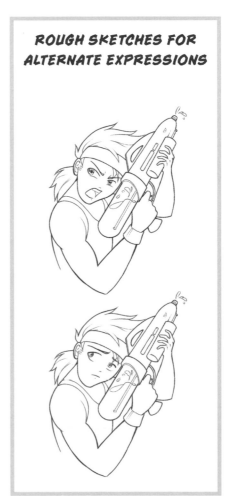

ROUGH SKETCHES FOR ALTERNATE EXPRESSIONS

CYBER-OKEMIA

Cyber-Okemia lives life on the edge of a cyber-punk metropolis,
fighting for the future of her world.

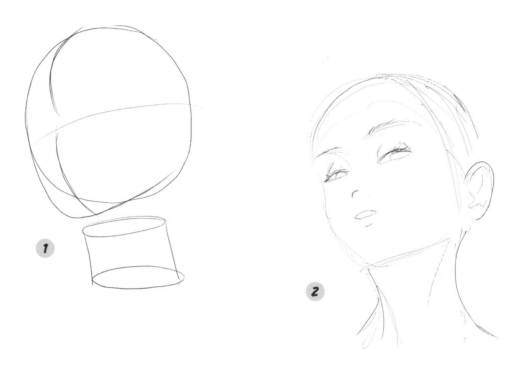

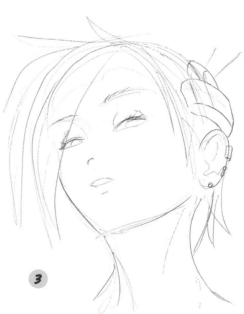

TIP: Drawing heads from low angles is much easier to achieve if you learn to break down a head into its basic shapes first. Don't hesitate to make adjustments if some things appear to be in the wrong place.

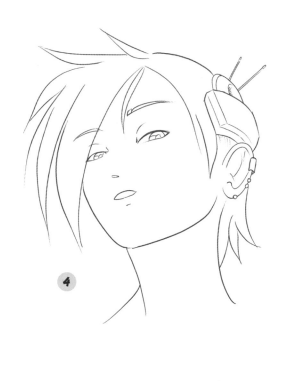

4

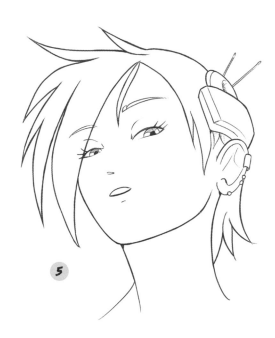

5

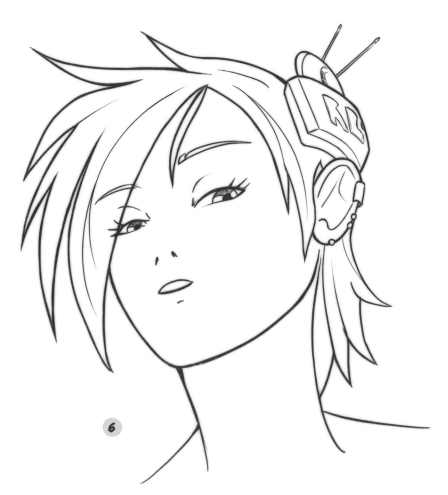

6

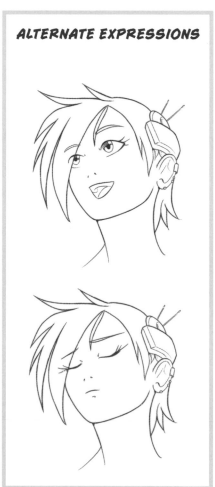

ALTERNATE EXPRESSIONS

JURO THE WARLOCK

Spells are very important to Juro, who believes that his arcane powers make a positive difference to the people in his medieval village.

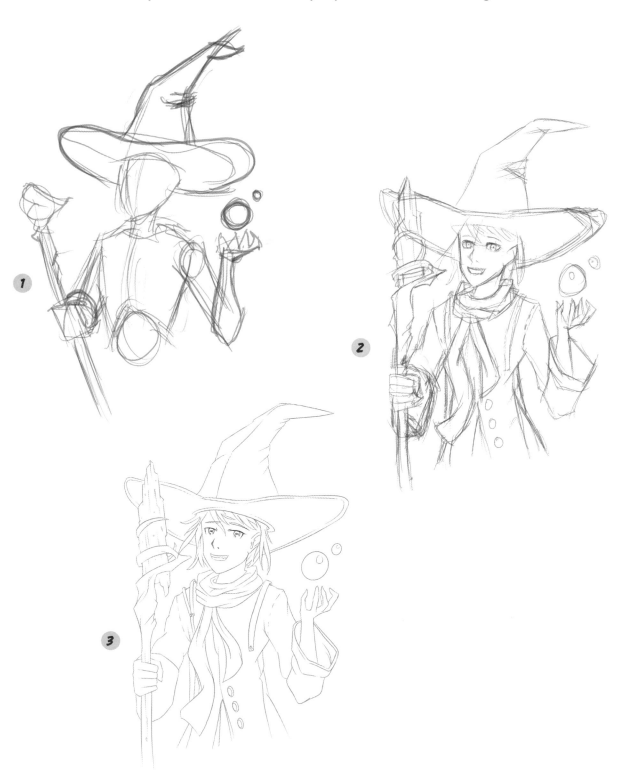

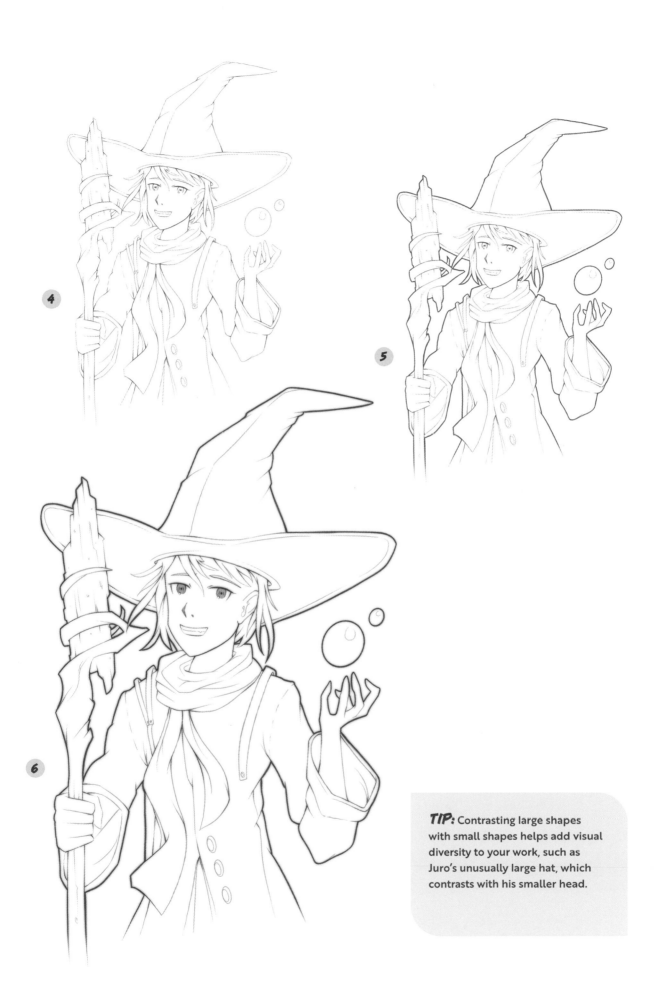

TIP: Contrasting large shapes with small shapes helps add visual diversity to your work, such as Juro's unusually large hat, which contrasts with his smaller head.

SATOKO, RETRO SPACE CHIBI

Going to space has always been Satoko's dream, but she didn't imagine she'd find aliens this early!

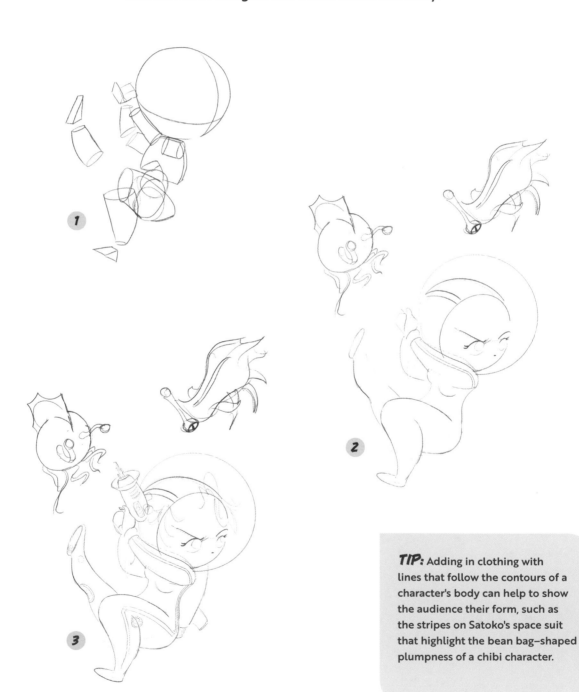

TIP: Adding in clothing with lines that follow the contours of a character's body can help to show the audience their form, such as the stripes on Satoko's space suit that highlight the bean bag–shaped plumpness of a chibi character.

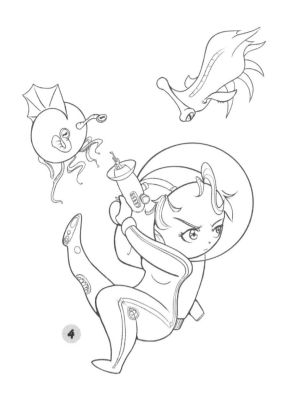

4

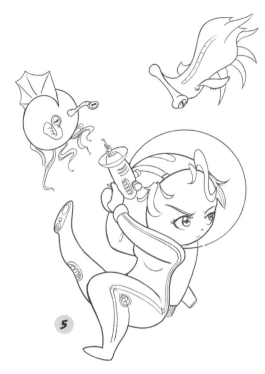

5

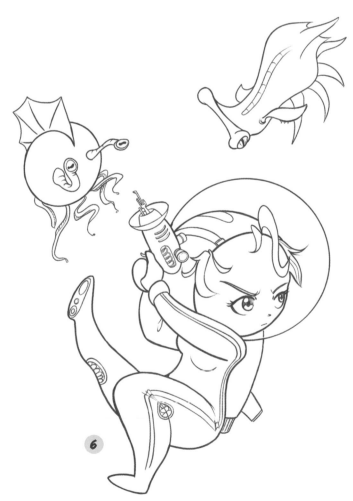

6

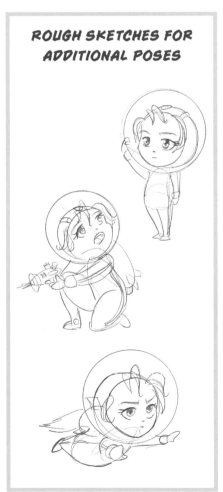

ROUGH SKETCHES FOR
ADDITIONAL POSES

SPACE WARRIOR KOHAKU

Kohaku, a space warrior who carries an ancient space weapon, is shown in a combat/battle pose.

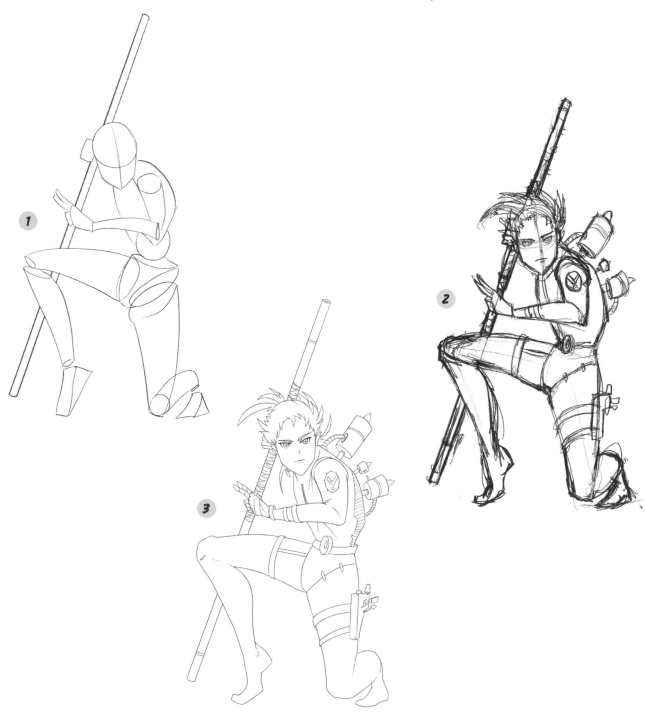

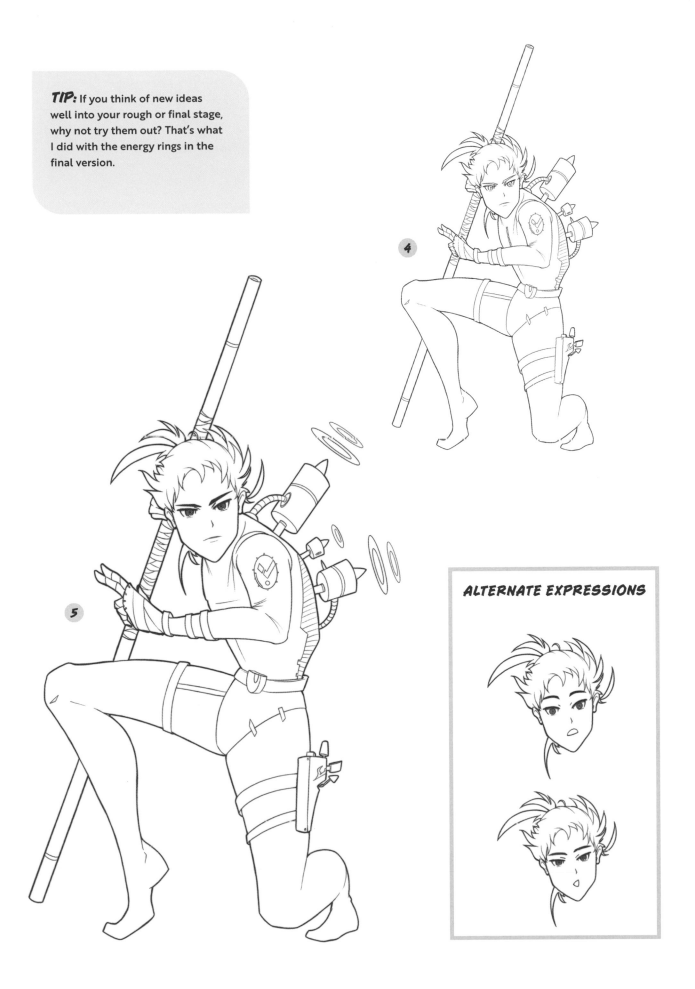

TIP: If you think of new ideas well into your rough or final stage, why not try them out? That's what I did with the energy rings in the final version.

4

5

ALTERNATE EXPRESSIONS

TAKI THE MECHA PILOT

A character who loves exploring virtual reality worlds,
Taki fits right into a video game–themed manga!

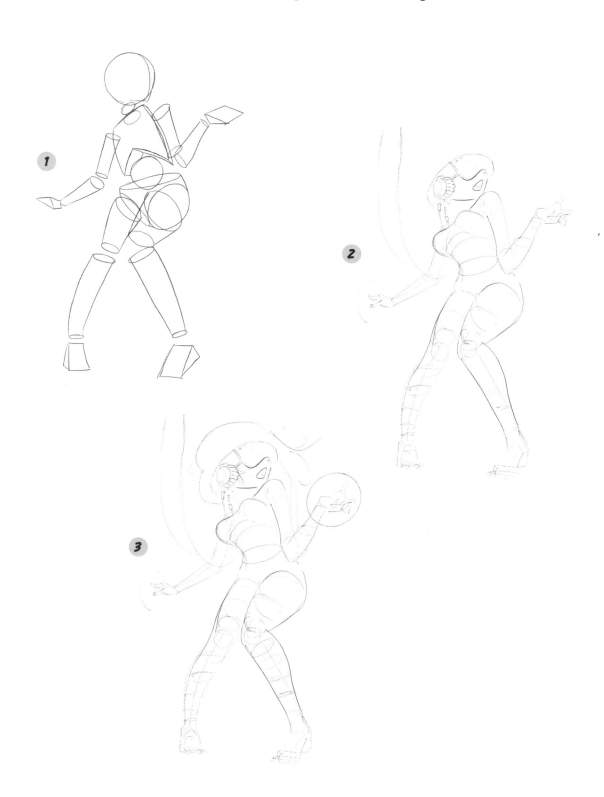

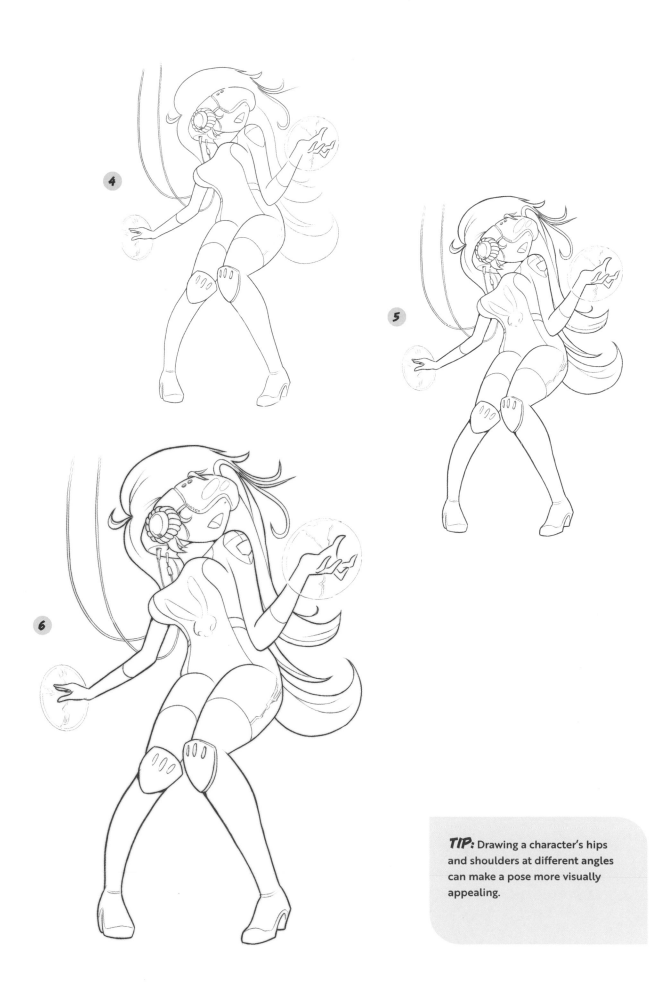

TIP: Drawing a character's hips and shoulders at different angles can make a pose more visually appealing.

KITSUNE THE FOX GIRL

Kitsune is a cute, foxy chibi girl, waiting for her next grand manga adventure!

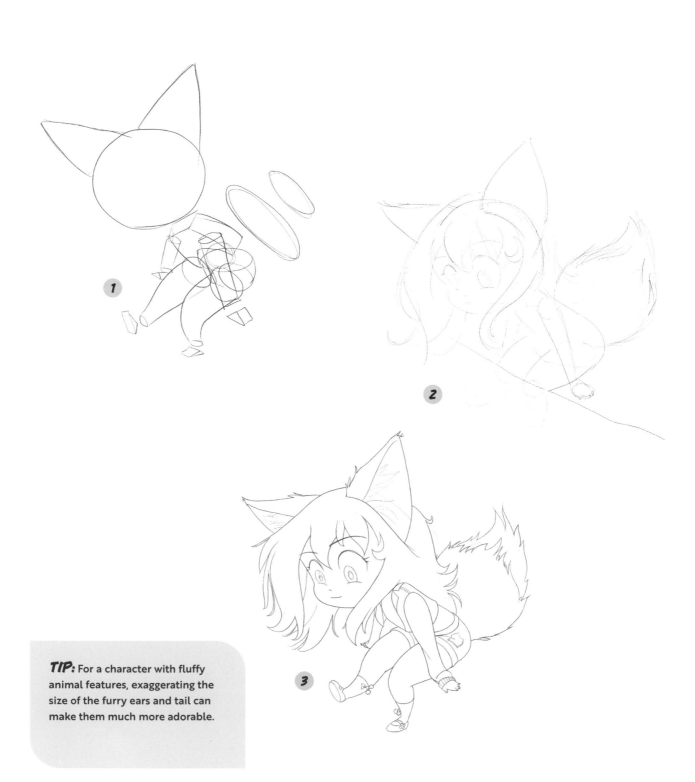

TIP: For a character with fluffy animal features, exaggerating the size of the furry ears and tail can make them much more adorable.

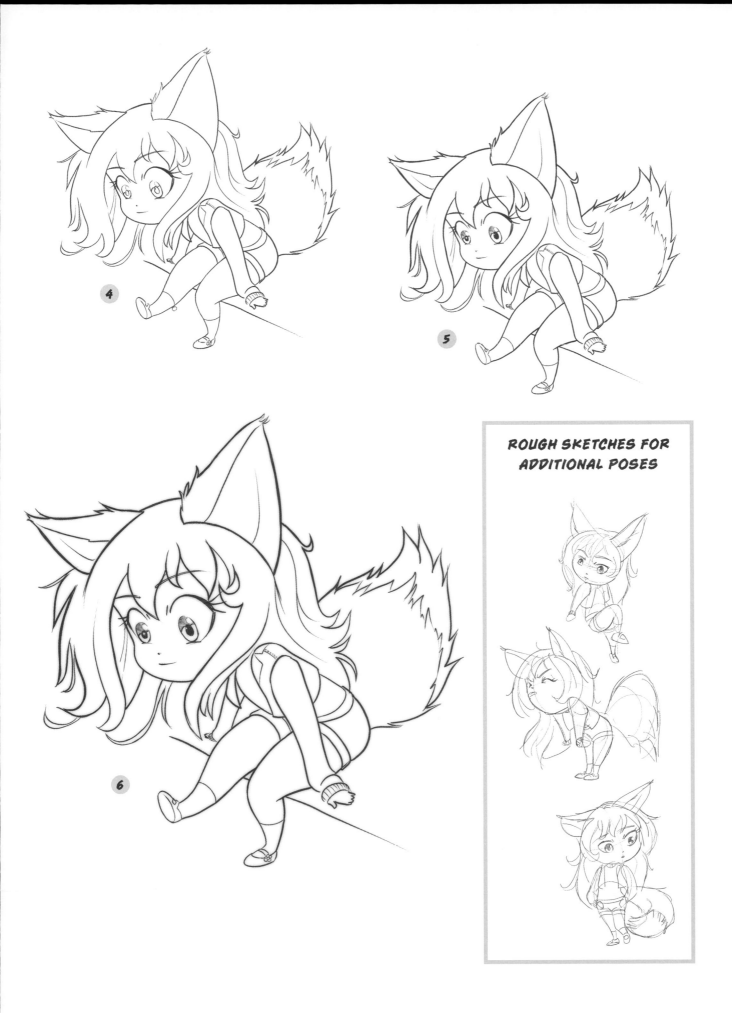

ROUGH SKETCHES FOR ADDITIONAL POSES

4

5

6

CRYSTAL REALMS UTA

Let Uta's crystal powers be the next great addition to your hero team manga series.

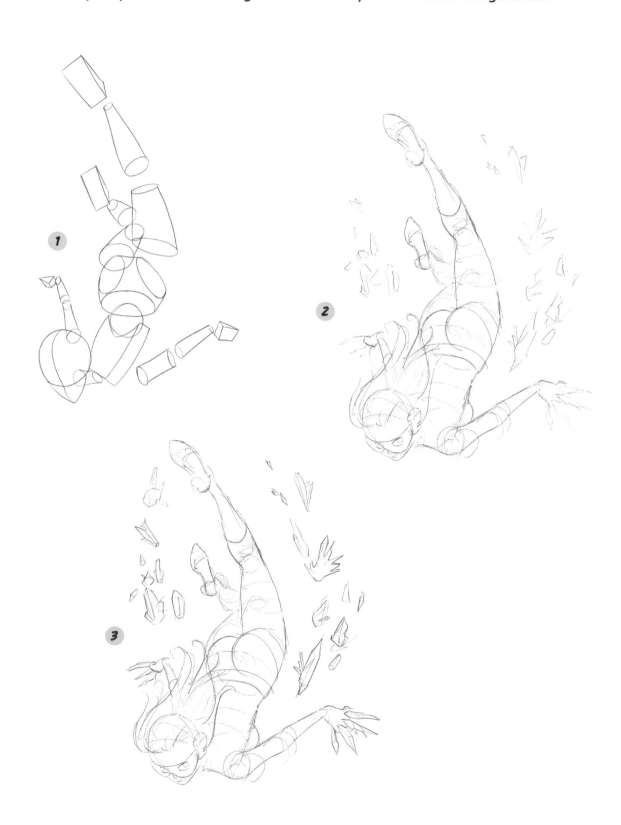

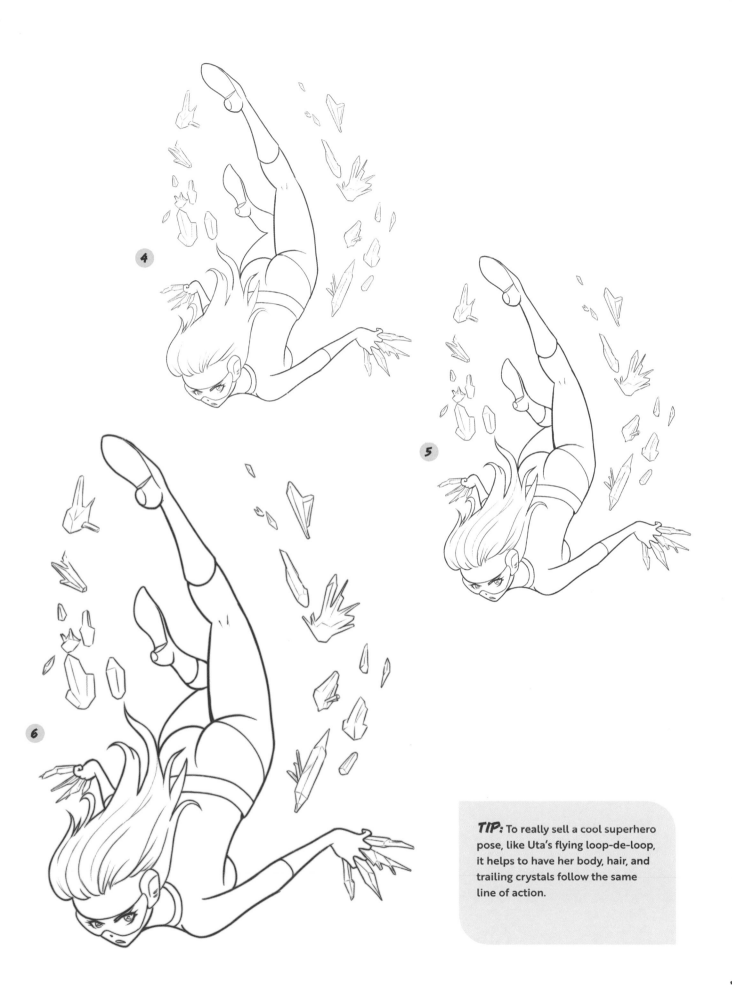

TIP: To really sell a cool superhero pose, like Uta's flying loop-de-loop, it helps to have her body, hair, and trailing crystals follow the same line of action.

STREET CHIC YUNA

Yuna is a trendy girl with a lot of attitude,
a perfect main character in any everyday manga story.

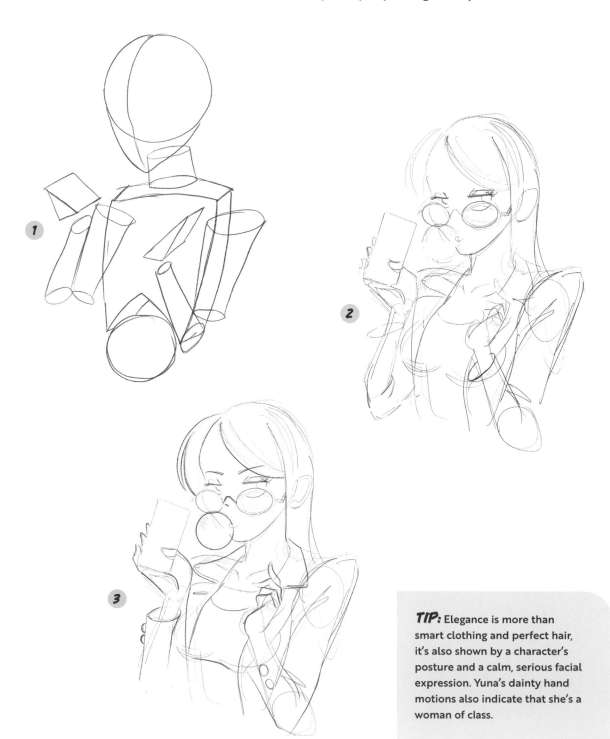

TIP: Elegance is more than
smart clothing and perfect hair,
it's also shown by a character's
posture and a calm, serious facial
expression. Yuna's dainty hand
motions also indicate that she's a
woman of class.

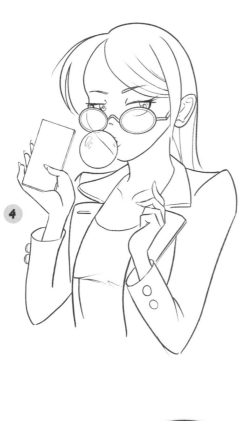

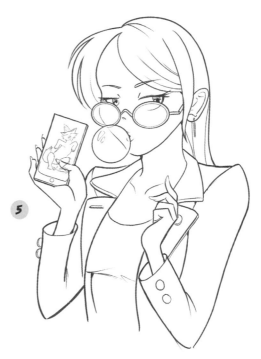

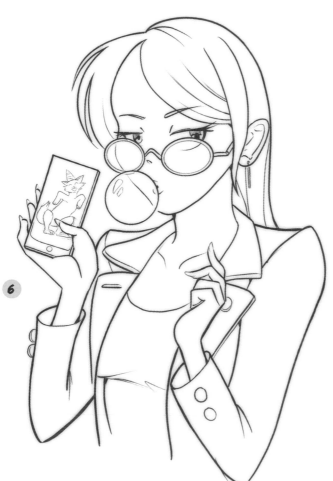

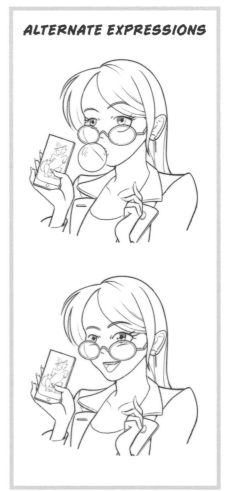

ALTERNATE EXPRESSIONS

THREE FRIENDS

Get inspired by three ninjas who just happen to be friends! Ninjas and ninja clans are a big part of many manga stories, so you can always find inspiration for your ninja drawings.

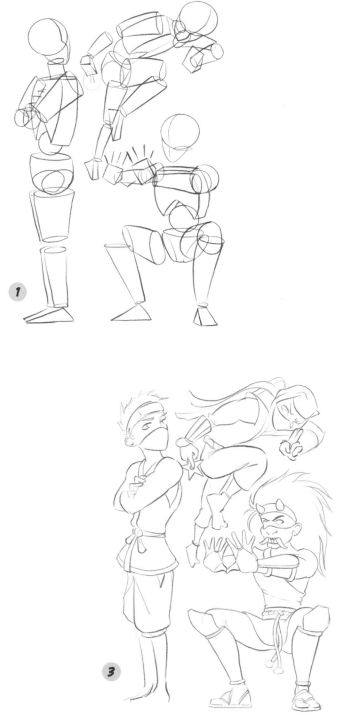

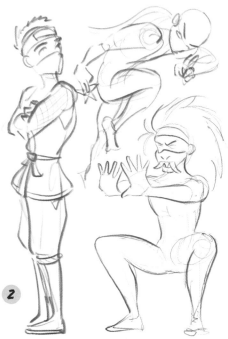

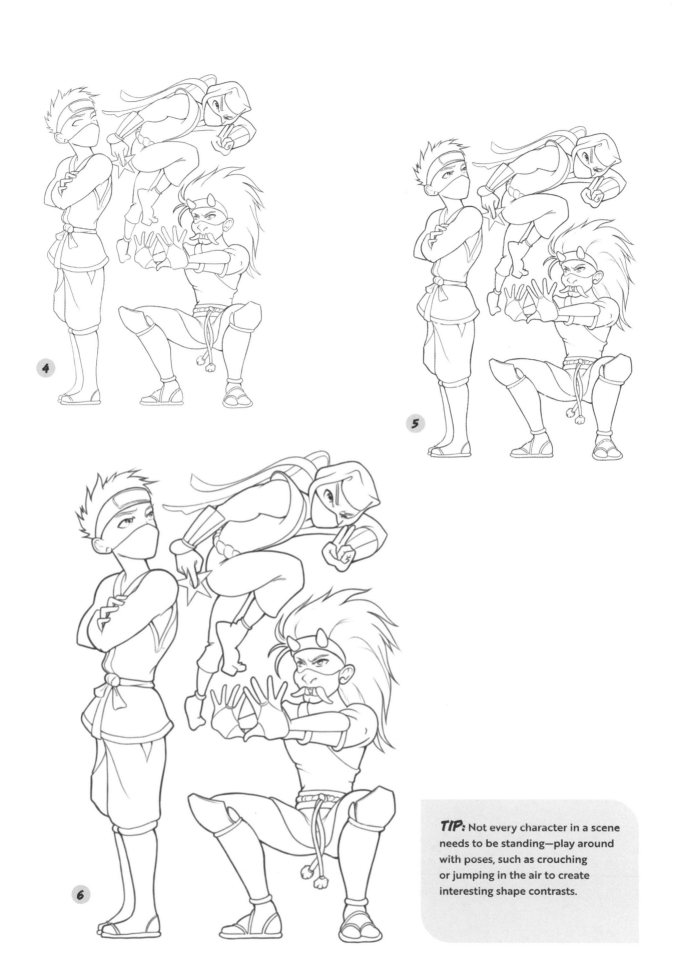

TIP: Not every character in a scene needs to be standing—play around with poses, such as crouching or jumping in the air to create interesting shape contrasts.

BEAUTIFUL SAKURA, CLASSIC FESTIVAL GIRL

Sakura is a manga character suited to being an antagonist in a comedy series; true to her name, she accessorizes with cherry blossoms.

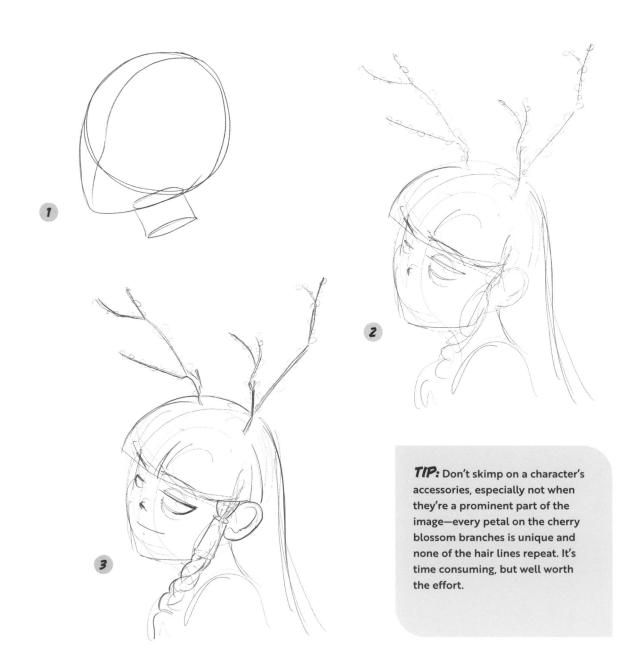

TIP: Don't skimp on a character's accessories, especially not when they're a prominent part of the image—every petal on the cherry blossom branches is unique and none of the hair lines repeat. It's time consuming, but well worth the effort.

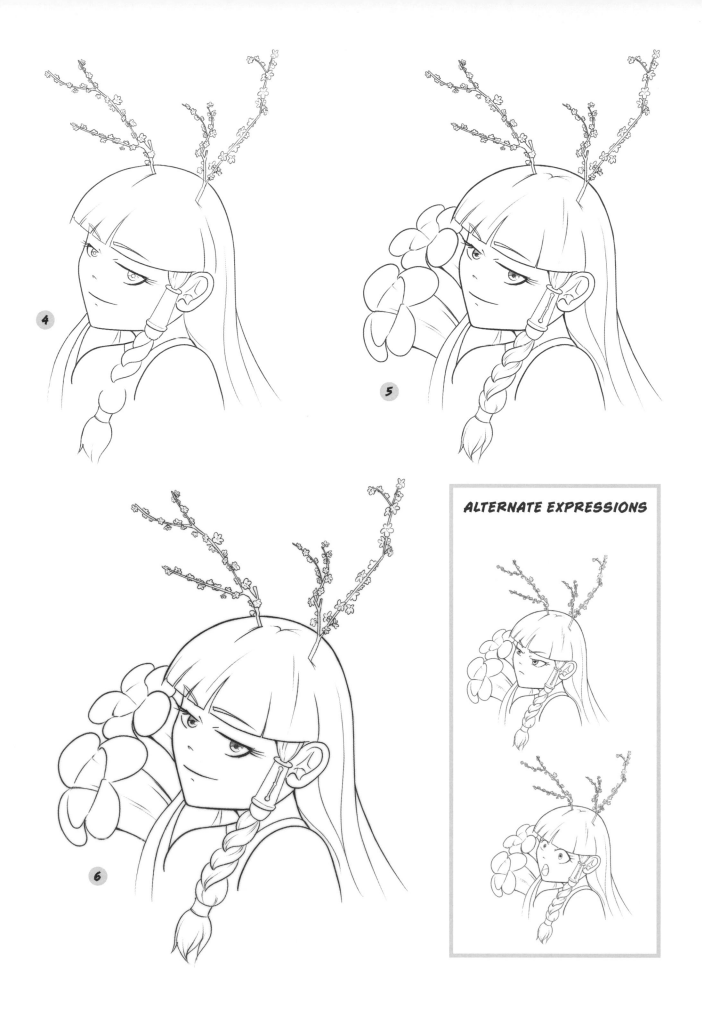

ALTERNATE EXPRESSIONS

VI THE VAMPIRE

Vi is an ancient vampire who lives in a tower atop a stony castle. He is able to control bats with just the power of his mind and is an excellent addition to any gothic manga story.

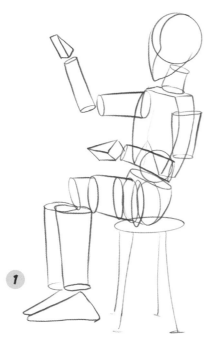

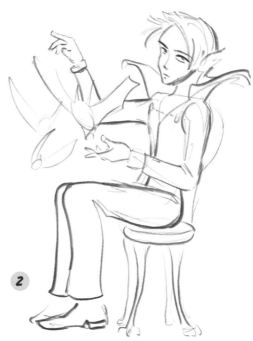

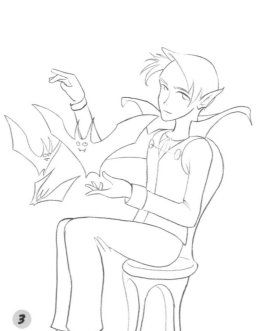

TIP: Hands are excellent secondary focal points and can help create a visual loop between the face, which is the focal point. This type of loop keeps the viewer engaged with the image.

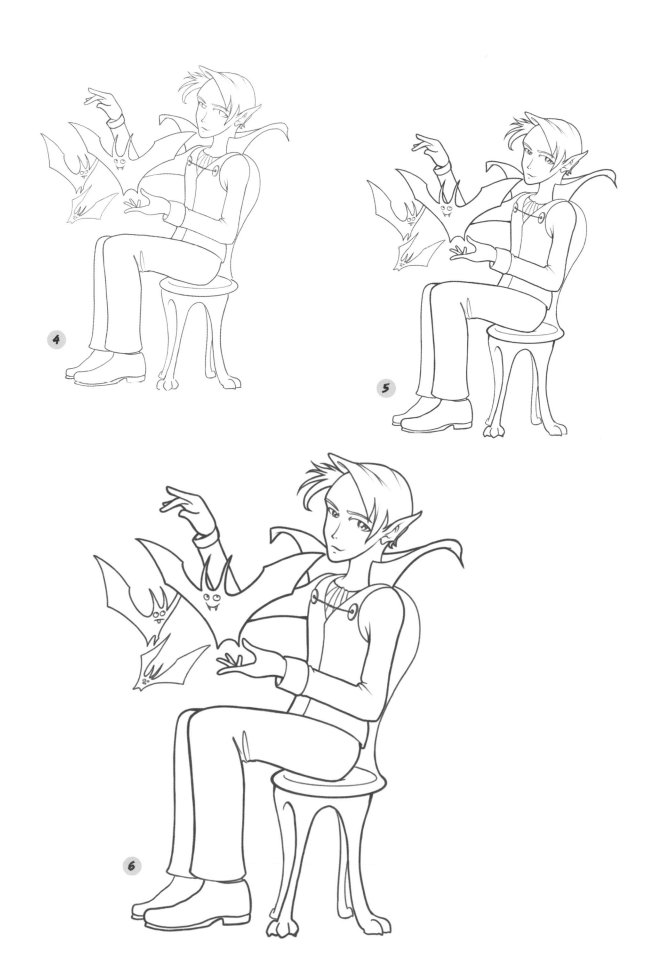

RAI THE MAGICAL PRINCESS

She could be from a cute new video game or a fantastical animated series,
but there's no mistaking the sparkle Rai brings!

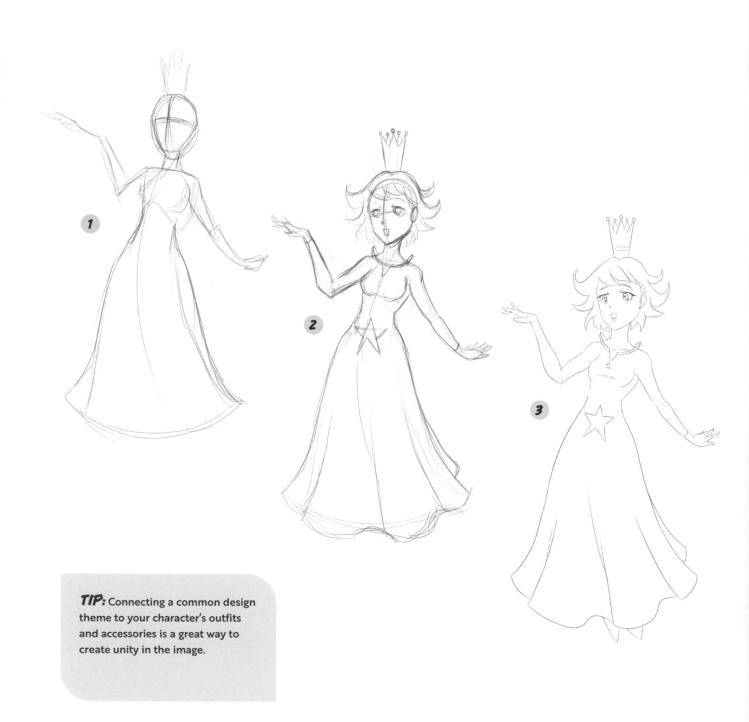

TIP: Connecting a common design theme to your character's outfits and accessories is a great way to create unity in the image.

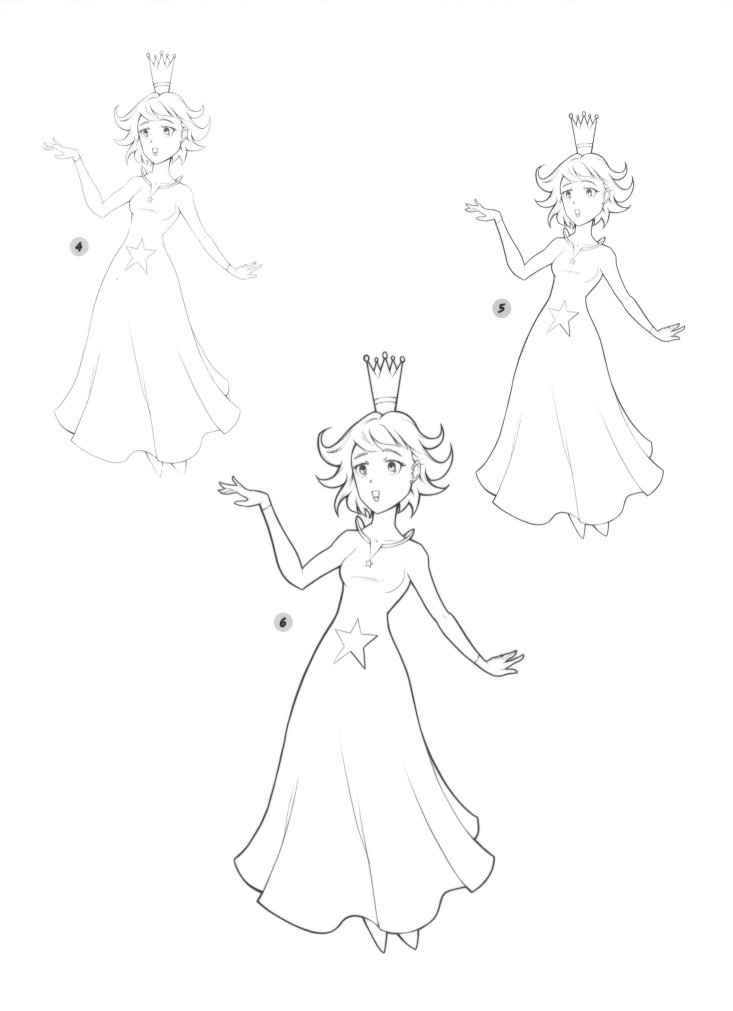

PIRATE CAPTAIN OKIMI

In a world of pirates and scallywags, anything can come as a surprise to young Captain Okimi, leader of the dandy delinquents and friend to his wacky parrot, McFrisby-chan.

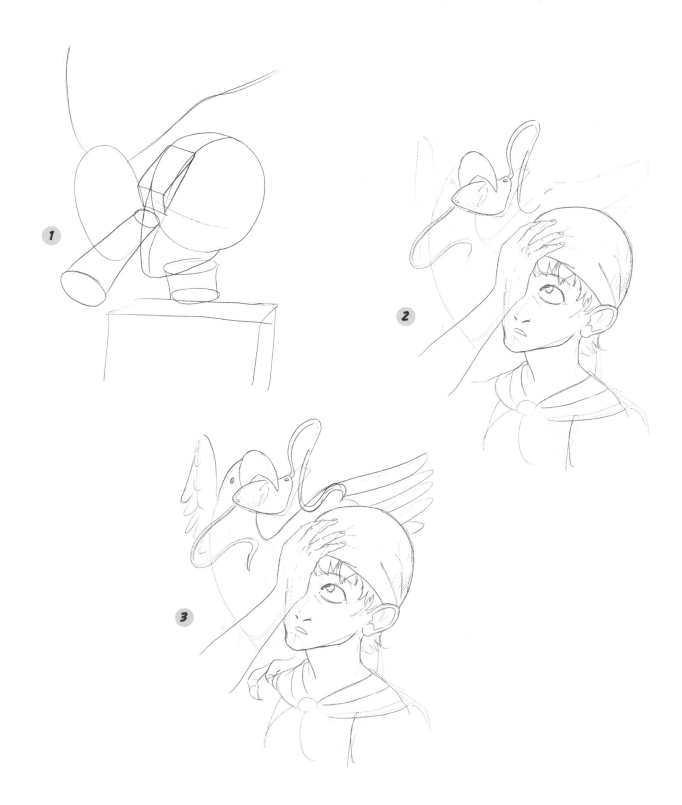

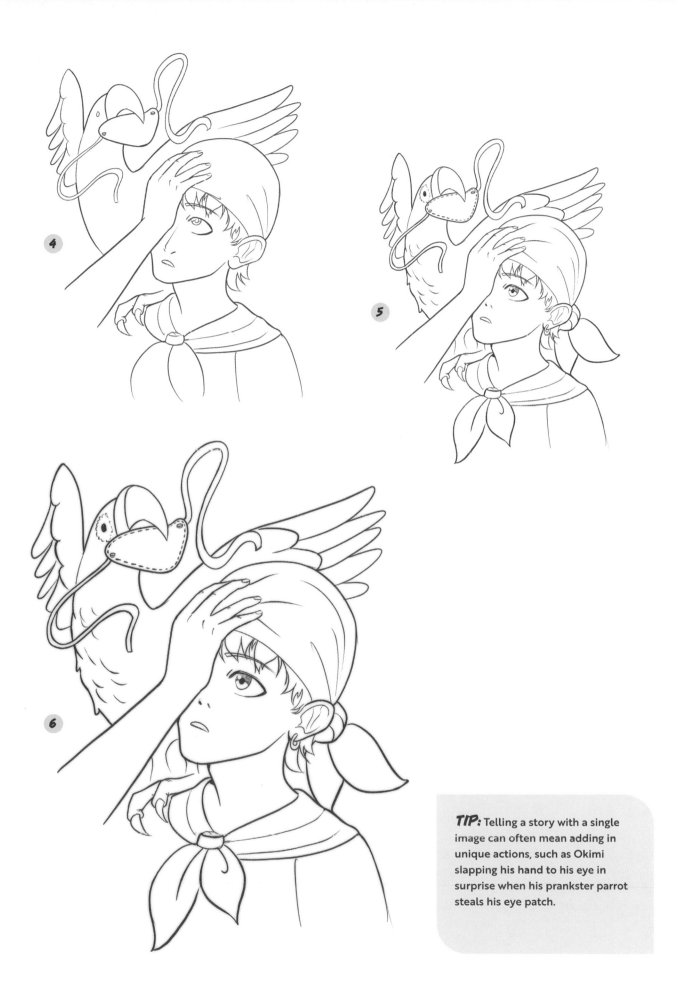

KOKO THE PUNK SKATER GIRL

Koko is a girl with an attitude and a passion for skateboarding and would be a great fit for an extreme sports–themed manga.

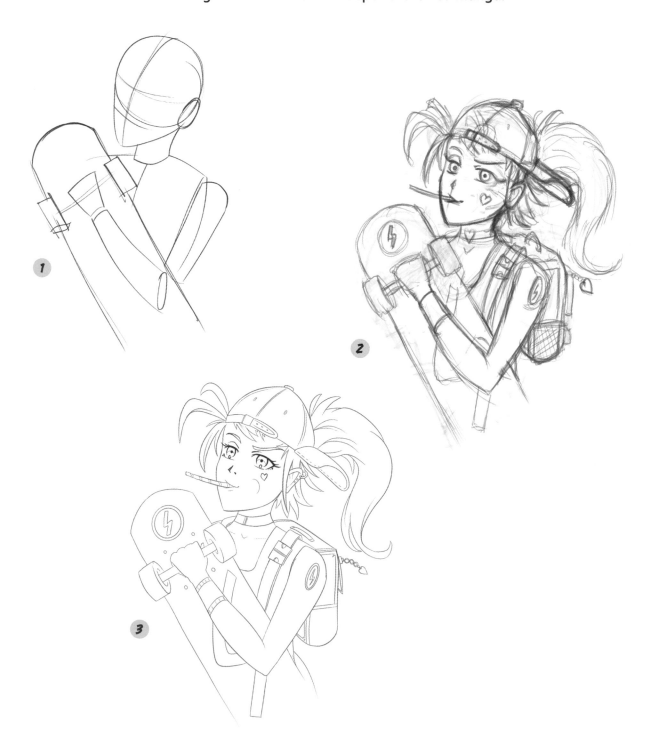

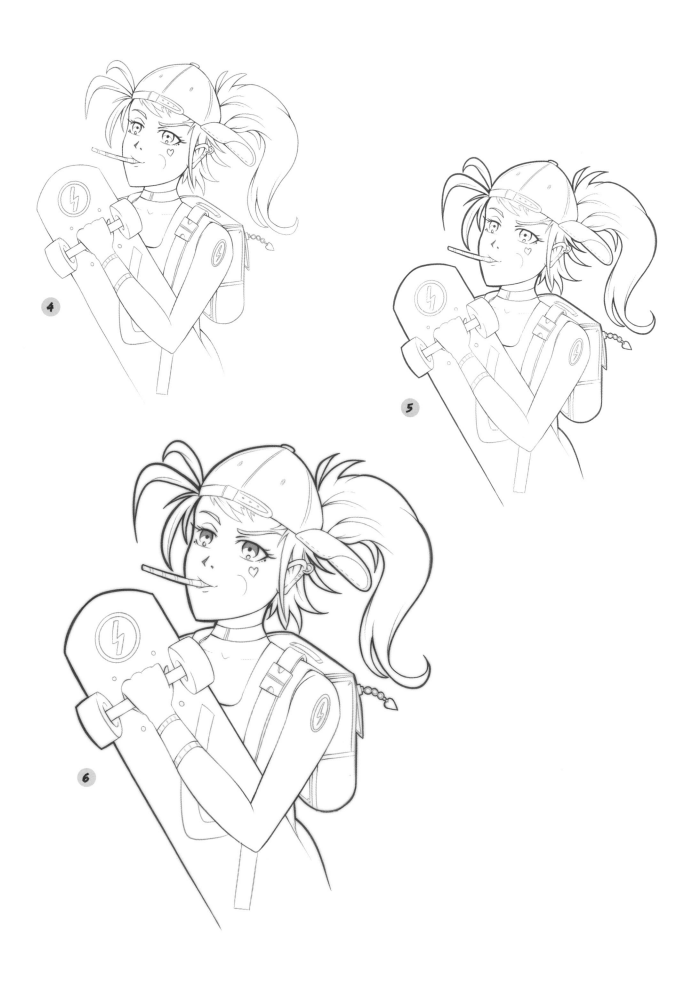

HINATA AT HOME

Hinata is ready to go out for a night on the town and makes sure her hair is just right!

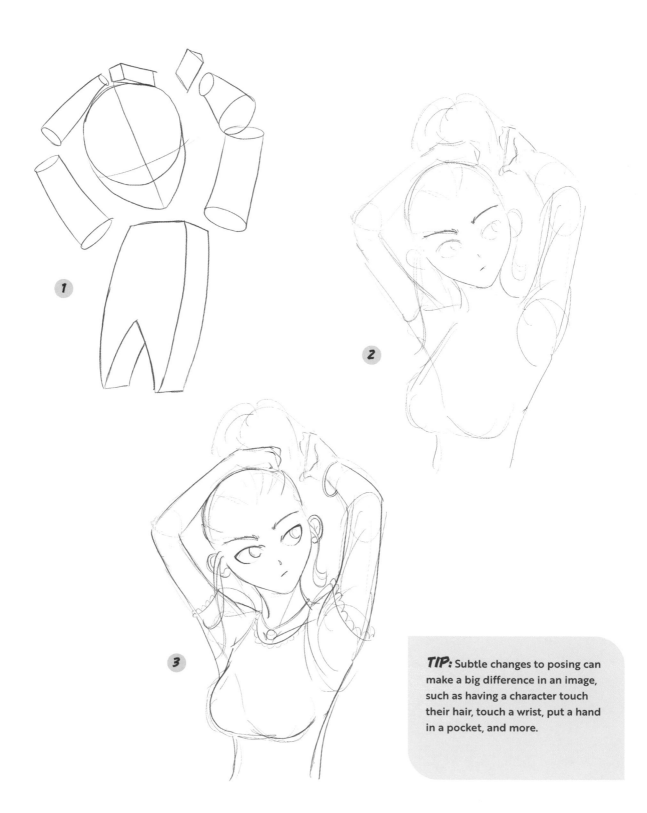

TIP: Subtle changes to posing can make a big difference in an image, such as having a character touch their hair, touch a wrist, put a hand in a pocket, and more.

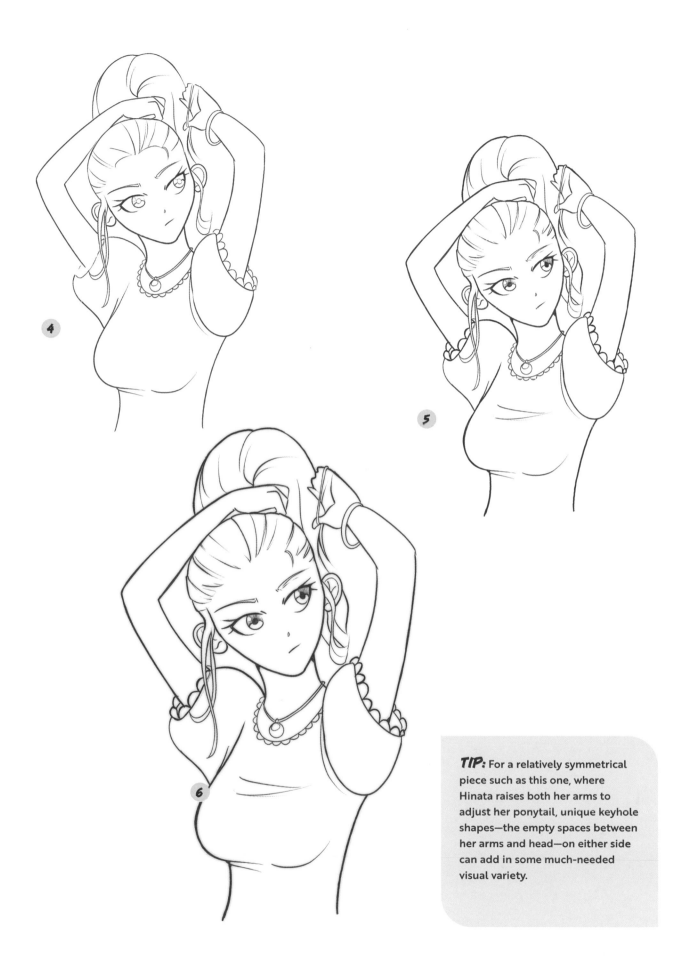

TIP: For a relatively symmetrical piece such as this one, where Hinata raises both her arms to adjust her ponytail, unique keyhole shapes—the empty spaces between her arms and head—on either side can add in some much-needed visual variety.

ROMANTIC CHIASA AND KOICHI

In this drawing, a dating couple is captured in a Valentine's Day kiss.

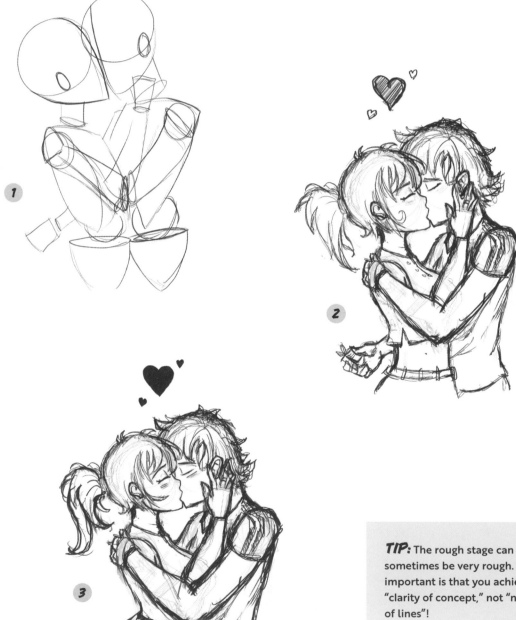

TIP: The rough stage can sometimes be very rough. What's important is that you achieve "clarity of concept," not "neatness of lines"!

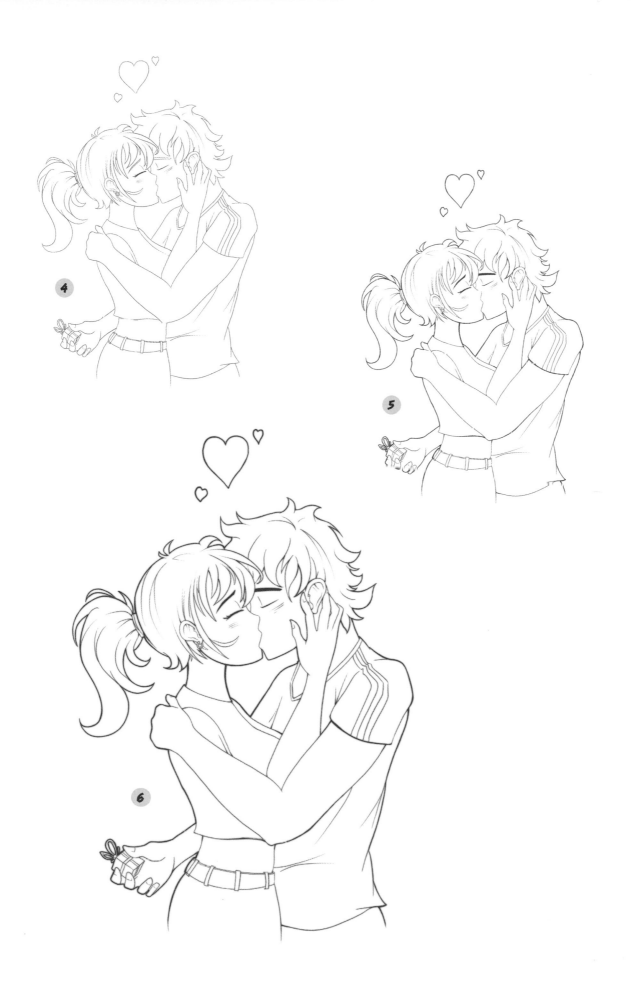

ABOUT THE AUTHOR

Scott Harris is an illustrator, painter and art instructor. He has taught hundreds of thousands of students to grow their art skills with his courses on ArtSchoolofImagination.com. Whether you're drawing characters, creatures, making manga or comics, painting portraits, or creating video game art, Scott teaches the core art knowledge you need to know. With years invested in learning and teaching art fundamentals, Scott has been able to structure art education in an efficient, easy-to-learn way. A passionate artist and zealous teacher, he strives to bring students to a high level efficiently, with simple, easy-to-understand concepts.

Inspiring | Educating | Creating | Entertaining

Brimming with creative inspiration, how-to projects, and useful information to enrich your everyday life, Quarto Knows is a favorite destination for those pursuing their interests and passions. Visit our site and dig deeper with our books into your area of interest: Quarto Creates, Quarto Cooks, Quarto Homes, Quarto Lives, Quarto Drives, Quarto Explores, Quarto Gifts, or Quarto Kids.

© 2021 Quarto Publishing Group USA Inc.
Text and illustrations © 2021 Scott Ronald Harris

First Published in 2021 by Quarry Books, an imprint of The Quarto Group,
100 Cummings Center, Suite 265-D, Beverly, MA 01915, USA.
T (978) 282-9590 F (978) 283-2742 QuartoKnows.com

Quarry Books titles are also available at discount for retail, wholesale, promotional, and bulk purchase. For details, contact the Special Sales Manager by email at specialsales@quarto.com or by mail at The Quarto Group, Attn: Special Sales Manager, 100 Cummings Center, Suite 265-D, Beverly, MA 01915, USA.

10 9 8 7 6 5 4 3 2 1

ISBN: 978-0-76037-221-0

Digital edition published in 2021
eISBN: 978-0-76037-222-7

Library of Congress Control Number: 2021942324

Design: Debbie Berne
Page Layout: Megan Jones Design
Illustrations: Scott Harris
Additional Illustrations: Matthew Vice

Printed in China